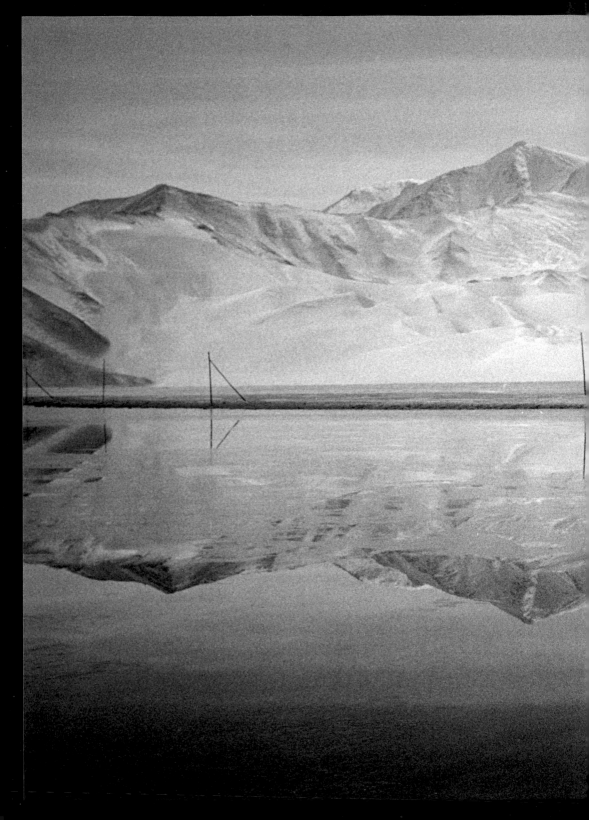

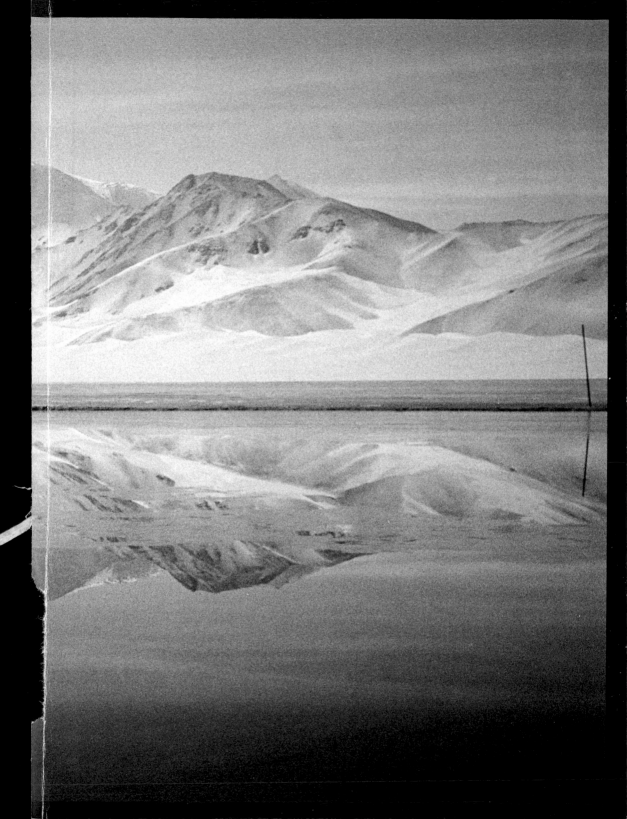

Chinese Turkestan

PHOTOGRAPHS
BY

Ryan Pyle

RYAN PYLE
PRODUCTIONS

A
photographic
journey
through an
ancient
civilization

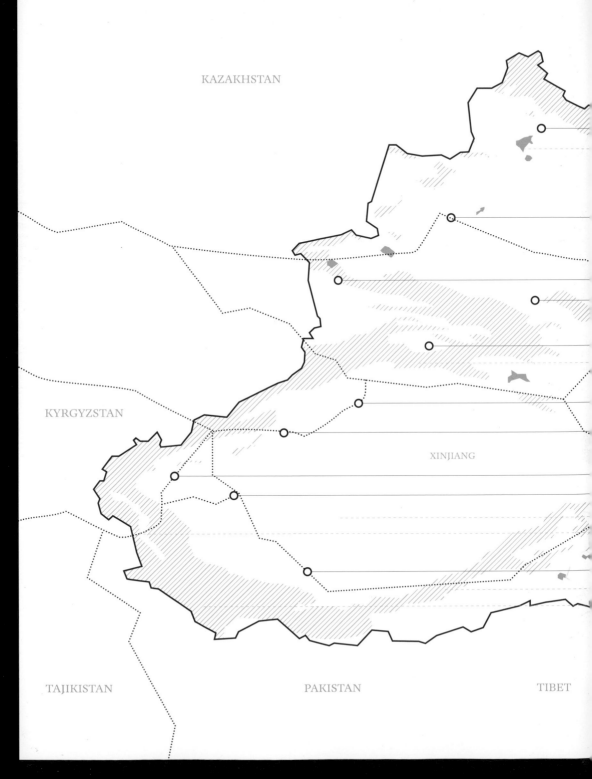

KAZAKHSTAN

KYRGYZSTAN

XINJIANG

TAJIKISTAN

PAKISTAN

TIBET

Map of Chinese Turkestan

MONGOLIA

ALTAY
Fuhai

KARAMAY

YINING
URUMQI

HAMI
BAYAN BULAK
Tian Shan Mountains

KUCHA

AKSU

KASHGAR
YENGISAR

Taklamakan Desert
Karakoram Highway

KHOTAN
Kunlun Mountains
Pamir Mountains

Silk Road Route

QINGHAI

△
N

Introduction

by
Ryan Pyle

Sparsely populated and spanning more than 1.6 million square kilometers of desert, river basins, mountains, and grasslands, the Xinjiang Uyghur Autonomous Region has had a turbulent history. Many of the events that have occurred there during the last 2500 years have been inextricably associated with its geographical position in northwest China, at a crossroads linking Europe and Asia.

Traversed by branches of the series of trade routes that formed the ancient Silk Road, the region has been fought over and controlled by a succession of warlords and empires that included Tocharians, Xiongnu, Xianbei, Kushan, Han, Tang, Tibetan, Uyghur, Mongolian, Turkic, Yuan, and Qing. By the seventeenth century, Mongolian animism, Tibetan Buddhism, and Nestorian Christianity had been largely superseded by Islam, which remains the primary religion in Xinjiang today.

During the seventeenth and early eighteenth centuries, the occupying Zunghars built stone-walled towns in the north and expanded trade with Russia. After the Zunghars came the Qing, who mined iron and copper, opened textile shops and lumber yards, and developed roads and mountain passes that enabled Chinese merchants to export tea, jade, and silver in exchange for gems, furs, opium, and livestock.

During the early part of the nineteenth century, the initially small Chinese population of Xinjiang began to increase. Following a steep decline in the mid-1800s, the numbers rose again. Although

Muslim Uyghurs currently remain in the majority, many believe that the continuing influx of Han Chinese is a direct result of the government's determination to ensure that they will soon be outnumbered. Inevitably perhaps, ethnic tensions periodically erupt into violence, and during the last decade there have been numerous riots and bomb attacks by Muslim Uyghurs and separatists who oppose policies imposed on them by the Chinese government in Beijing.

With the most recent influx of Han Chinese have also come transformations in the character of Xinjiang's cities: shopping malls now replace ancient bazaars, and new apartment blocks rise above what remains of the old laneways. In reality, the people of Xinjiang are facing many changes. Their future, as well as the future of this culturally and geographically unique territory, may depend on how those changes are dealt with.

Despite the contentious issues that exist in Xinjiang, it wasn't for any political reasons that I chose to call this book Chinese Turkestan. It was simply because, for me, the old name conjures up a region without physical borders; an admixture of an idea rather than a distinct geographical or political entity.

I know there will be people who ask, 'How can you produce a book about Xinjiang that doesn't highlight its political and ethnic tensions? How can you not care about what's happening there?' The simple answer is that I do care. But I am a humble photographer. Even after all the visits I've made to Xinjiang, I still have only a superficial

understanding of the complex problems that underlie the many frustrations and conflicts.

So, instead of pontificating on a subject that it would take a lifetime fully to comprehend, I've done what I do best: I've observed, documented, and shared. I hope this book of photographs will supplement and augment the information provided by newspaper articles and TV news items about part of the world few outsiders will ever really know.

It was in August 2001, just after I'd graduated from the University of Toronto, that I began to plan my first visit to China. The following month, the World Trade Center in New York was destroyed in a devastating attack by Islamic terrorists. A month after that, the US and its allies became involved in a war in Afghanistan, which still continues today.

Before I left Canada, I didn't really discuss with anyone the details of what was in effect just a rough itinerary. It wasn't until I got to Beijing that I told people I was planning to go to the primarily Muslim region of Xinjiang, and then everyone I spoke to said pretty much the same thing: 'Don't go. It's really dangerous out there.'

I knew very little about Xinjiang before I arrived in China on that first visit. I hadn't yet read The Travels of Marco Polo, the book that for more than 700 years has inspired countless adventurers and explorers. And in 2001 there was little information to be found on Wikipedia, which had been launched earlier that year and bore little resemblance to the constantly updated bank of more than 30 million articles it is today. What I did know about Xinjiang was confined to what I'd read and heard on the news about the bombings and terrorist attacks that occur there intermittently, and to some basic history related to the ancient Silk Road, which extends for almost 6500 kilometers from China to the Mediterranean.

In view of my lack of any detailed knowledge, I don't know why I felt compelled to visit Xinjiang. But there I was in China, not knowing if I'd ever return, and I didn't want to miss what might prove to be my only opportunity to see part of the country that was clearly something of an enigma. Maybe it was because I was so intrigued by the fact that there was an area of China with a substantial Muslim population of primarily mixed ethnicity that I decided to ignore the warnings, keep a close eye on the news, and carry on as planned. It was a decision I was to be very glad I'd made.

After flying from Toronto to Hong Kong and then by train to Beijing, I traveled south to Xi'an, followed the Silk Road through Gansu Province to Turpan and on to Urumqi, and then continued by bus through the Tian Shan Mountains to Kashgar. I was captivated from the outset by everything I saw and experienced in Xinjiang — by the magnificent snow-capped mountains; the vast expanses of constantly shifting sands in the desert; the crowded, bustling markets, old laneways and mudbrick houses in the cities; and the small, remote farms in rural areas where the

style and pace of life have barely changed for hundreds of years.

Perhaps what fascinated me most of all, though, were the people. The majority of the inhabitants of Xinjiang are Uyghurs of Turkic ethnic origin and mixed European and East Asian ancestry. But there are also Han Chinese, Tajiks, Kazakhs, Kyrgyz, and Mongolians, who together form a genetic melting pot of the descendants of merchants, warriors, pilgrims, and nomads who, for centuries, traveled the Silk Road that linked China with India, Persia, Europe, and Arabia.

When I left Kashgar after my first visit in 2001, I was determined to return. A year later, I moved from Canada to Hong Kong and from there to Shanghai — where I still live today with my wife and family. Once I'd settled in Shanghai, I set about establishing a career as a photographer. Working mostly for North American and British newspapers and magazines, I was covering some interesting, sometimes exciting, stories; but they weren't my stories. Then, in 2006, I was commissioned to do a travel article about Kashgar. By that time, I'd read a couple of books and had been keeping track of what was happening in Xinjiang. Now, at last, I was going back. It was a moment I'd been looking forward to, and I wasn't disappointed.

After I'd completed the job in Kashgar, I stayed on for a few more days to make some pictures of my own. And that was when the idea came to me to start compiling a collection of photographs which would capture the essence of Xinjiang and document its extraordinary juxtaposition of timelessness and rapid change. What developed from that idea was a photography project into which I was able to put my heart and soul.

I've returned to Xinjiang many times since 2006; each time, I've learned more about it, and about the lives and aspirations of some of the people who live there. It has been a privilege to have had that opportunity.

When I started making the photographs in this book, part of my intention was to highlight the ethnic tensions and political situation that exist in the largest administrative district in China. But, as the project evolved, it developed a softer, more personal focus and eventually became a series of moments frozen in time. As well as showing aspects of people's daily lives, Chinese Turkestan depicts the culture and architecture of a region that one day in the not too distant future will have changed beyond all recognition.

China is currently in the throes of a modernization that is occurring at an unprecedentedly rapid rate. Before long, the skyscrapers that rise, Phoenix-like, from the rubble of demolition will render its cities almost indistinguishable from each other. Perhaps nowhere is this process of destruction and rebuilding more apparent than in Kashgar, where many of the old houses and laneways have already been demolished to accommodate the new way of life.

Throughout China, competition for jobs and education is now the main driving force. Like

parents everywhere, Chinese parents want their children to have better lives than they have had. And who's to say that, on some level at least, people's lives won't be improved by modernization, however soulless some aspects of it may seem in comparison to what is being torn down in Xinjiang today.

In Kashgar, the Chinese government is partially funding a project that involves pulling down the old mud-brick houses and rebuilding them with new bricks reinforced with steel to withstand seismic vibrations: apparently, the city is in an earthquake zone. Some of the people I talked to expressed resentment about the changing face of their city. Some are unhappy about the loss of their community and of a way of life that, until now, has remained almost untouched by the passing of time. Some people dislike the shiny white apartment blocks, which are now ubiquitous in almost every part of China; others welcome the opportunity to live in modern homes with heating, plumbed bathrooms, and natural gas for cooking.

For many people, modernization creates a dilemma: a more comfortable life versus the loss of their cultural heritage. So perhaps the main issues confronting the province of Xinjiang today are not those that exist between the Uyghurs and Han Chinese. Perhaps the real dichotomy is between traditional and modern: the pull of life in the city versus the hardships inherent in eking a livelihood from the soil in the way your father, grandfather, and great-grandfather did before you. The winds of change that are sweeping across the province – and across the rest of China – seem barely to have touched Xinjiang's rural areas.

I have traveled the globe extensively in my work as a photographer and as a television presenter and producer. Of all the many places I've visited, Xinjiang is the most redolent of contrasts, contradictions, and anachronisms. Photographing the faces of the people I met in the countryside – faces that reflect a wide diversity of heritage and ethnicity – taught me to look beneath the surface. When I did so, one of the things I discovered was that behind every face there is a personal story. The brick-maker's livelihood has been revitalized by the rebuilding project in Kashgar. The elderly farmer's children have grown up and moved to the city, leaving him to work the land alone. The young woman crouches in a field for hours every day holding her baby in one hand and picking cotton with the other. Another woman prays in a graveyard in the desert beside the grave of her recently deceased husband. And an old widow with no sons plants rice in the small paddy field that is her only, meager, source of income now her daughters have married and gone to live and work with their husbands' families.

Over the years, I often returned to Xinjiang to see families I'd met before. Sometimes their circumstances had barely altered. Sometimes their houses had been adapted or even destroyed. And sometimes they'd taken advantage of government-funded rebuilding projects, sold their homes in the old laneways, and moved into new apartment blocks.

There were many occasions when I stood in a crowded marketplace, enveloped in the early-morning haze of coal smoke amidst the cacophony of livestock traders, noodle, bread, and dumpling makers, blacksmiths, knife and carpet sellers, feeling like a time-traveler transported to some bygone era. In reality though, the signs of change are everywhere: although farmers may still use pick-axes to dig drainage canals on their land, in all but the remotest rural regions they have mobile phones and at least limited access to the internet.

My role as a photographer is not to comment on the 'rights' and 'wrongs' of what is happening in Xinjiang, but rather to document a way of life that a way of life that one day will no longer exist. This book is the embodiment of an idea that became a reality. It contains some of the photographs I took during many visits to Xinjiang over a period of 8 years; they are photographs I am proud to be able to share.

Chinese Turkestan

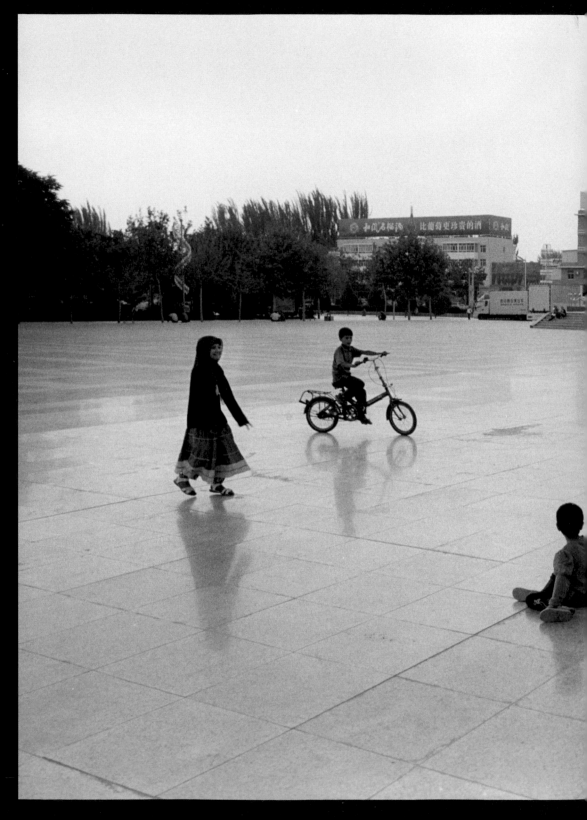

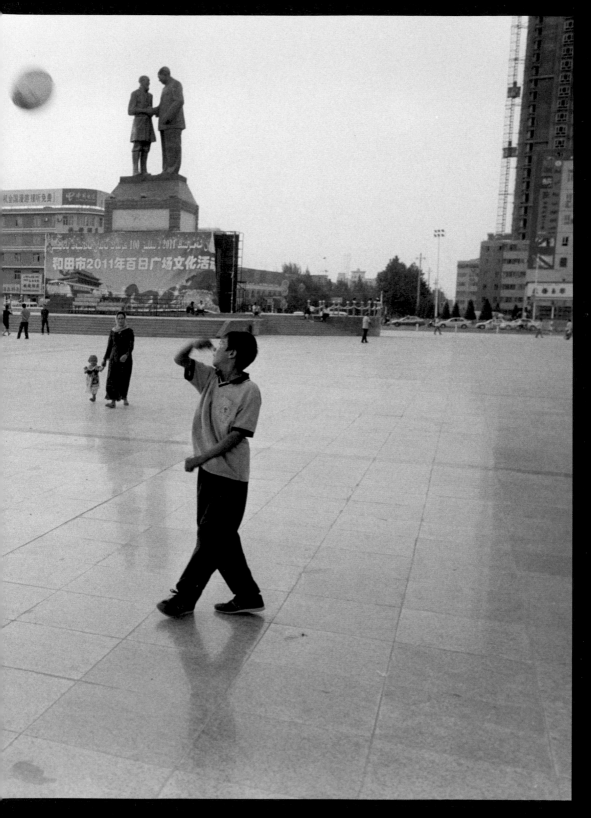

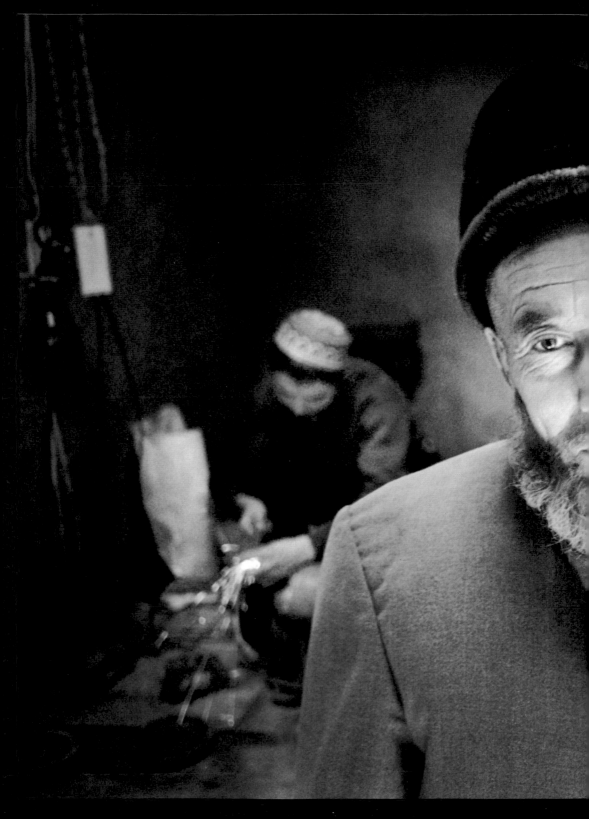

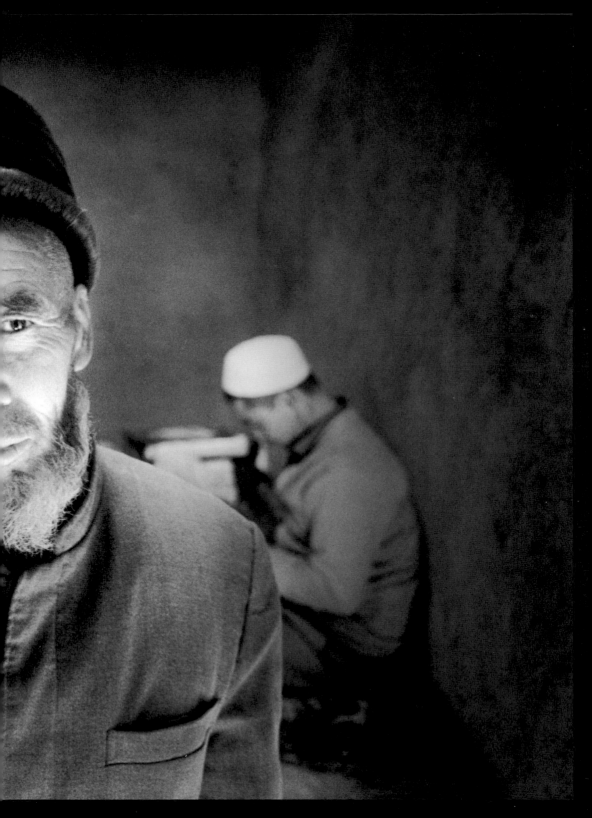

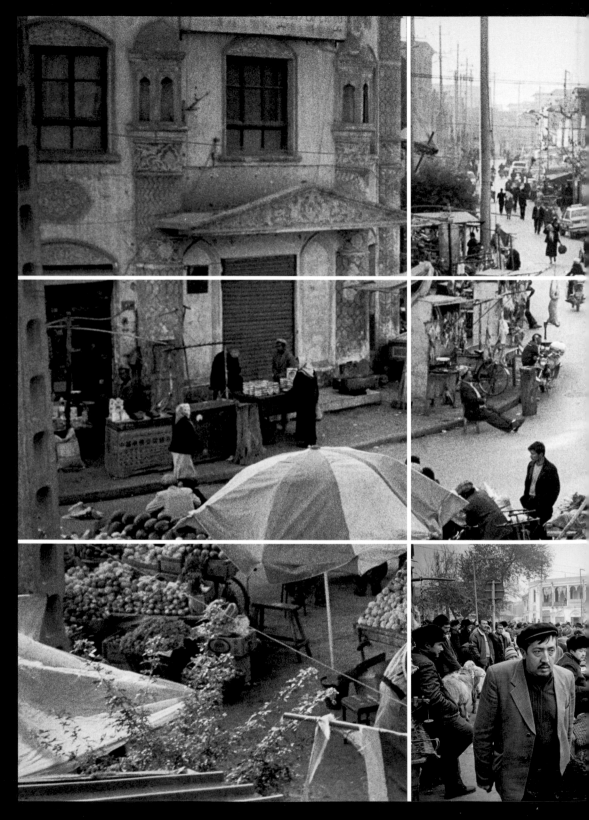

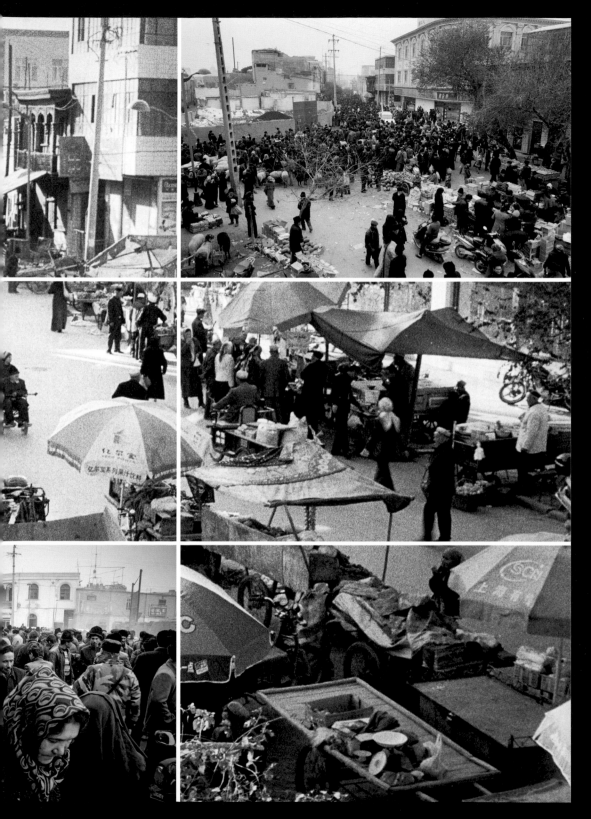

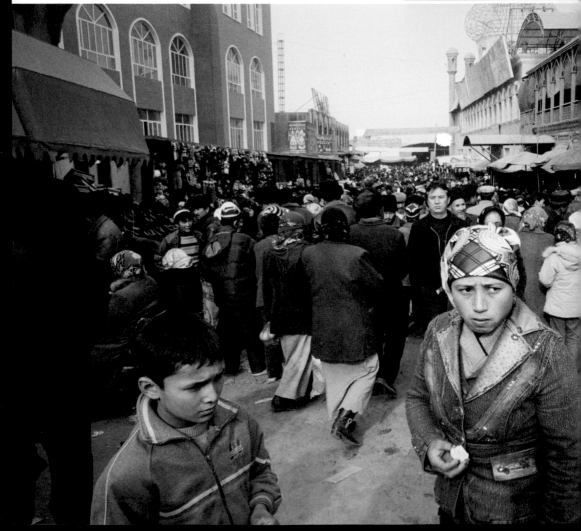

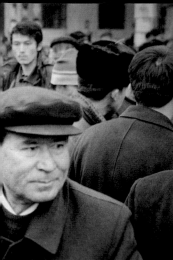

PAGES 24 — 25
A man plays with his children in Union Square in the oasis town of Khotan in the Tarim Basin. In the statue behind them, Mao Zedong shakes hands with a Uyghur man called Kurban Tulum.

PAGES 26 — 27
A man stands in his home in the countryside near Yengisar. Behind him, his two sons learn the craft of knife making, for which the town is renowned.

PAGES 28 — 29
MAIN IMAGE One of the many street markets in Kashgar.

TOP, RIGHT Uyghur Muslims fill the streets buying and selling sheep to slaughter, skin and gut as part of the celebration of the end of Ramadan, or Eid al-Fitr, in the old laneways of central Kashgar.

BOTTOM, CENTER Muslim shoppers in Kashgar at the start of Eid al-Fitr.

THIS PAGE
MAIN IMAGE The crowded entrance to the main market in Khotan.

TOP, CENTER The old laneways of Kashgar are crowded with men, and some women, preparing for Eid al-Fitr, the festival to mark the end of Ramadan.

BOTTOM, RIGHT The faces of people in this market in Khotan reflect the region's many ethnicities.

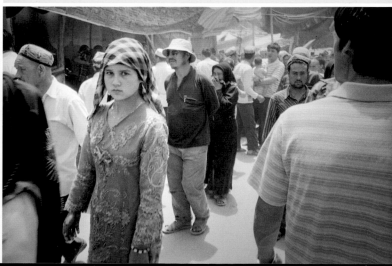

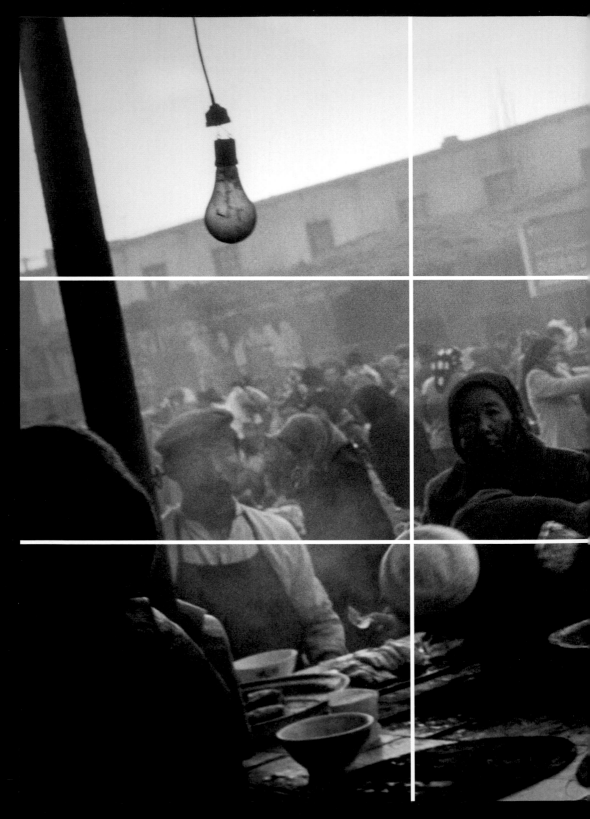

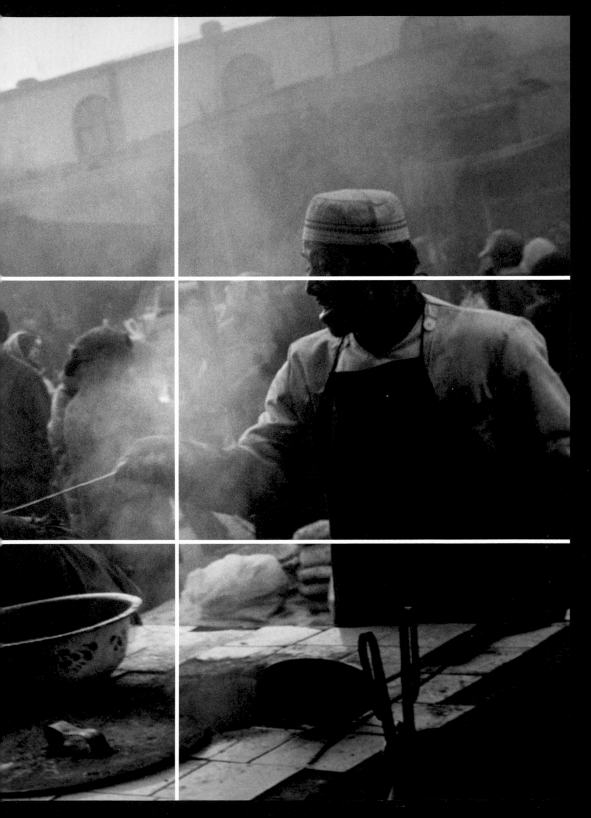

PAGES 32 — 33
A man bakes bread in a food market
in the city of Kucha.

THIS PAGE
LEFT A man sells bananas at the
main market in Kucha.

RIGHT An old man and his son
make meat dumplings in a food
market in Kashgar.

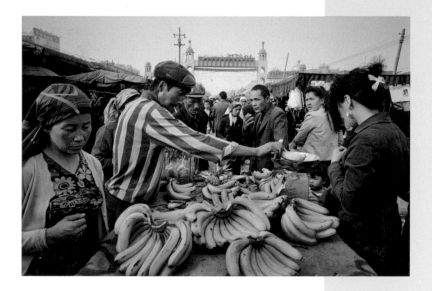

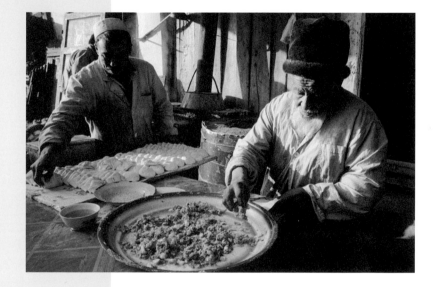

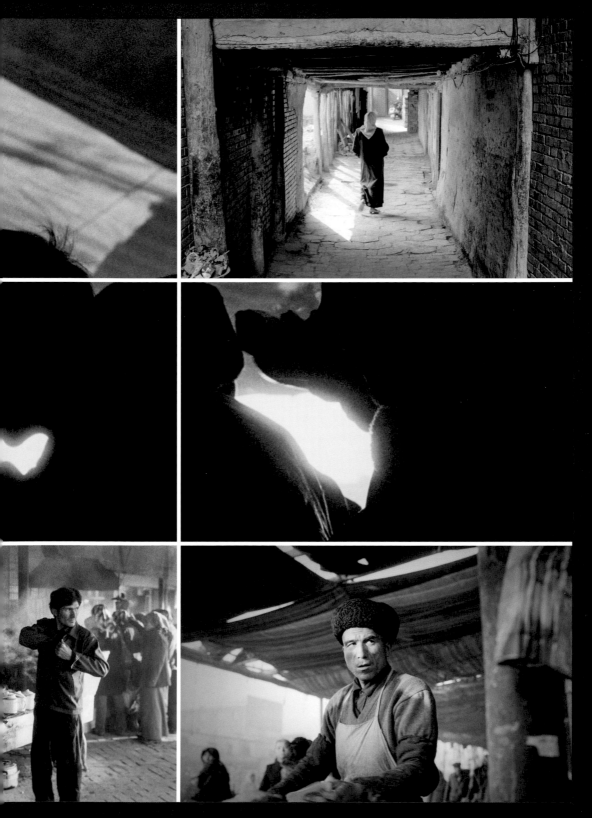

PAGES 36 – 37
MAIN IMAGE A boy waits to be
served with food in a market in
Kucha.

TOP, RIGHT A woman walks
through a deserted laneway in an
old neighborhood in central
Kashgar.

BOTTOM, CENTER A man reaches
for his wallet to pay for his food in a
market in Kucha.

BOTTOM, RIGHT A man cooks food
at a market in Kucha.

THIS PAGE
MAIN IMAGE A man strains
steaming noodles in the market in
Khotan.

BOTTOM, CENTER Meat dumplings
being prepared at a market in
Kucha.

BOTTOM, RIGHT A woman sells
dried beans in the food market in
Kashgar.

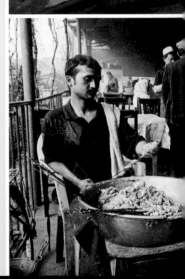

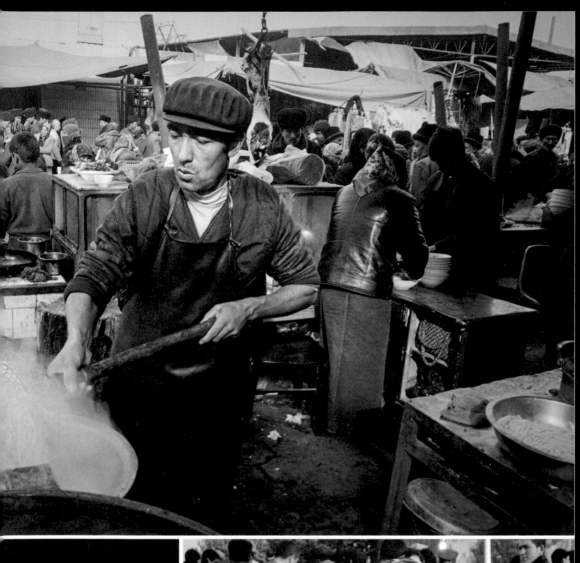
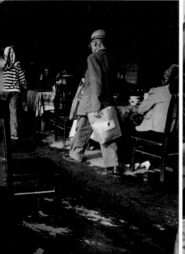
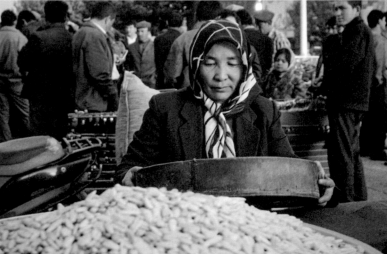

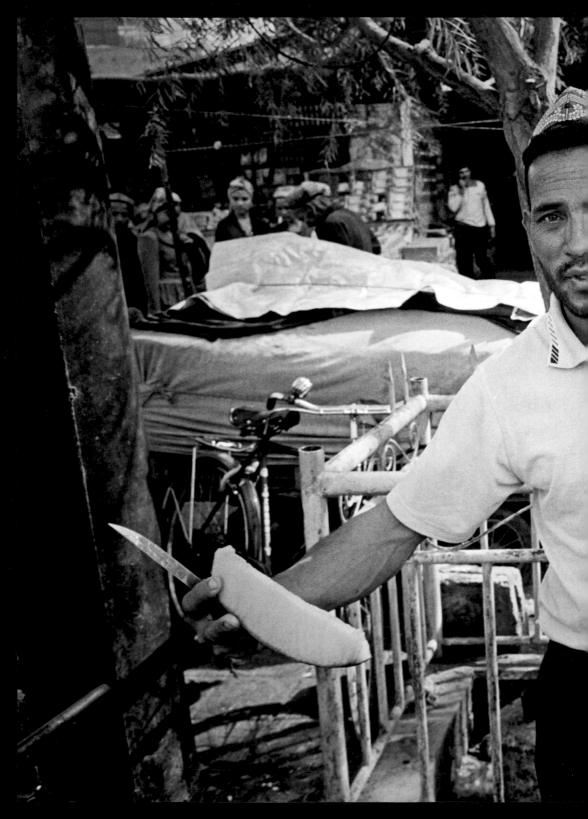

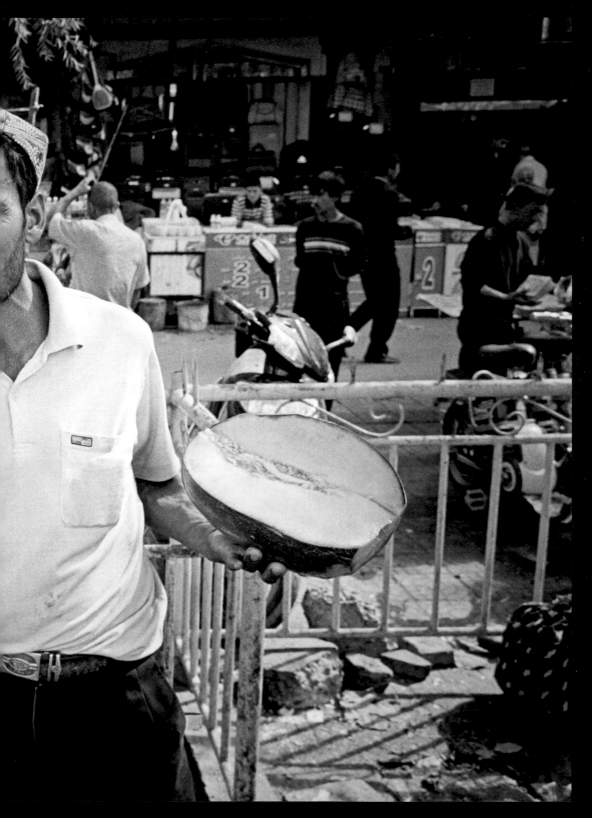

PAGES 40 – 41
A man sells melons, for which
Xinjiang is famous, in a market in
Kashgar.

THIS PAGE
LEFT A motorcycle taxi carries
passengers through the streets of
central Kashgar.

RIGHT The old laneways of
central Kashgar are even more
crowded than usual as people
prepare for Eid al-Fitr.

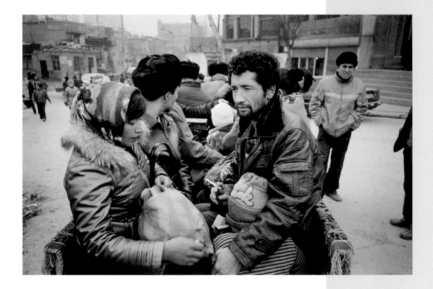

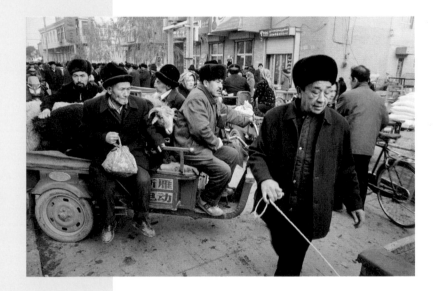

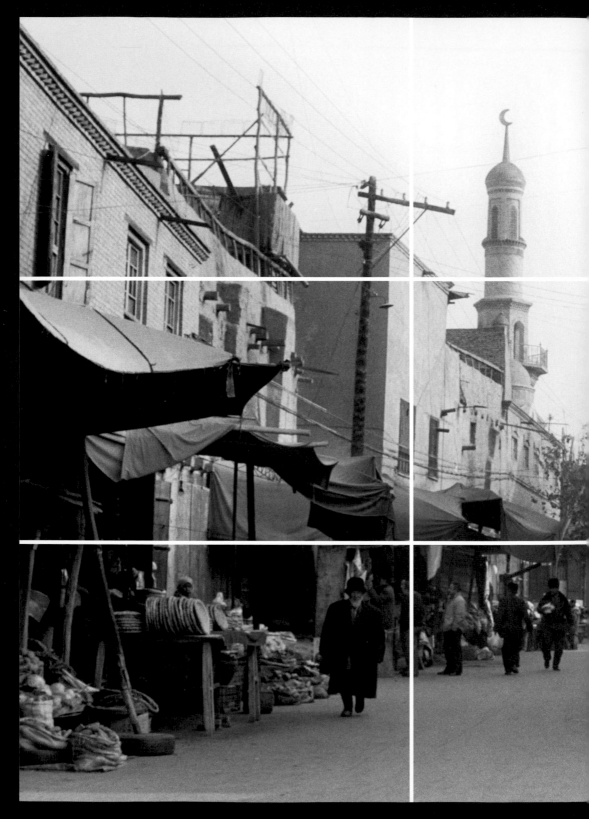

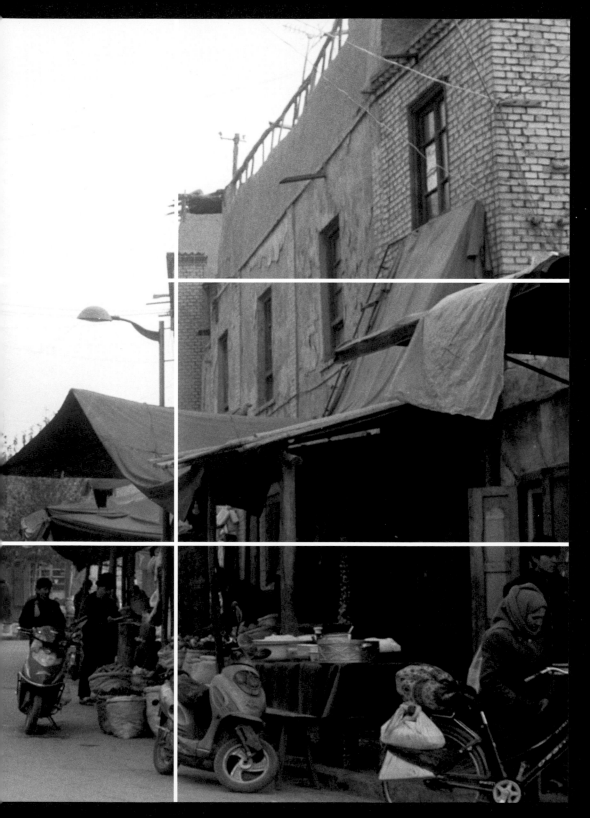

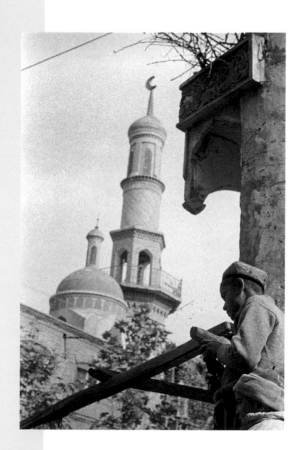

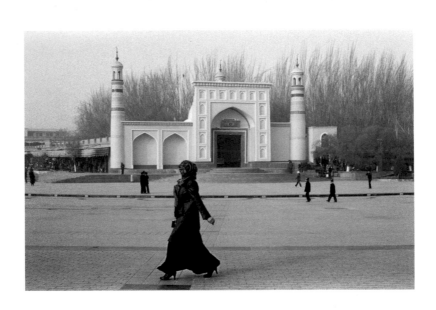

LEFT A woman walks past the Id Kah Mosque in Kashgar.

RIGHT Men leave the Id Kah Mosque in Kashgar after Friday prayers.

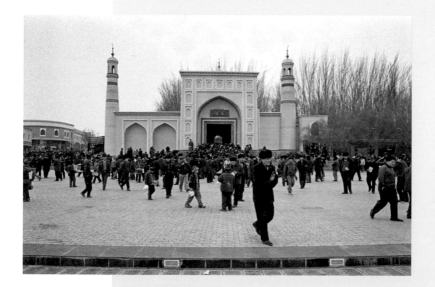

MAIN IMAGE Thousands of
Muslims pray together outside the
Id Kah Mosque in Kashgar in the
early morning at the end of
Ramadan.

BOTTOM, LEFT A man gives money
to a woman who is begging outside
the Id Kah Mosque in Kashgar after
Friday midday prayers.

BOTTOM, CENTER A woman begs
outside the Id Kah Mosque in
Kashgar.

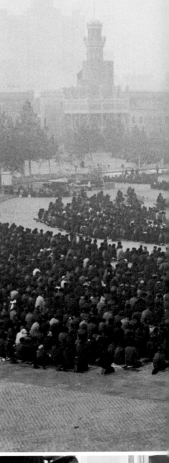

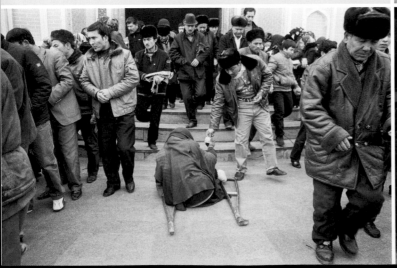

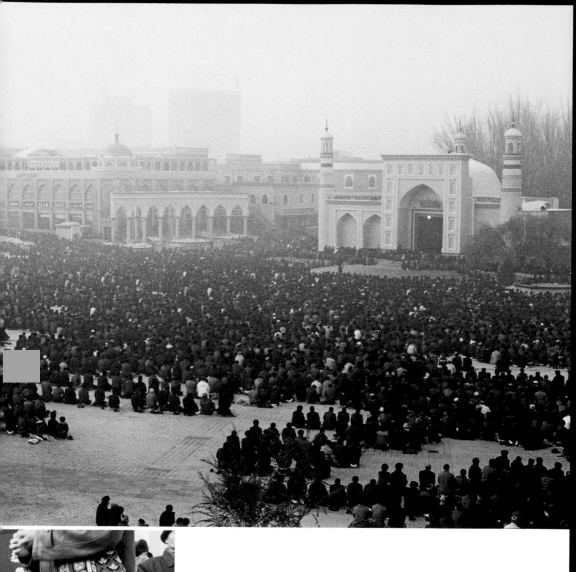

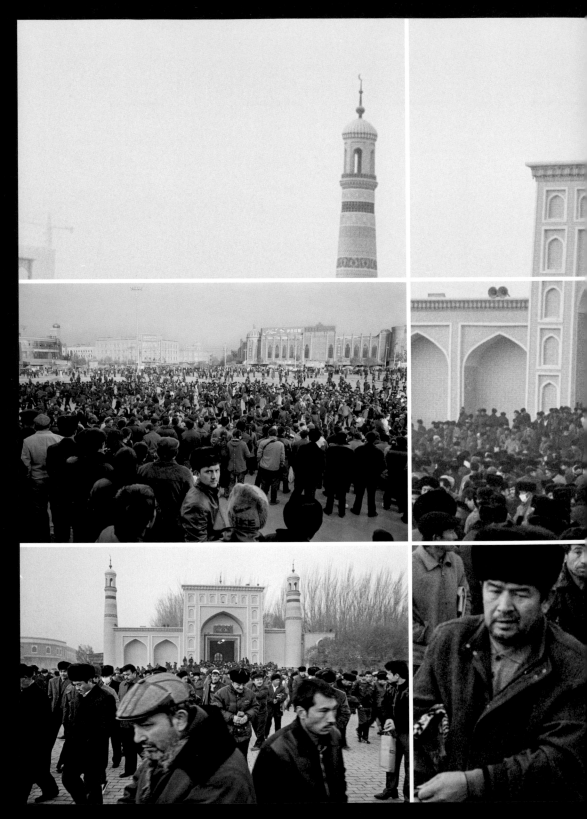

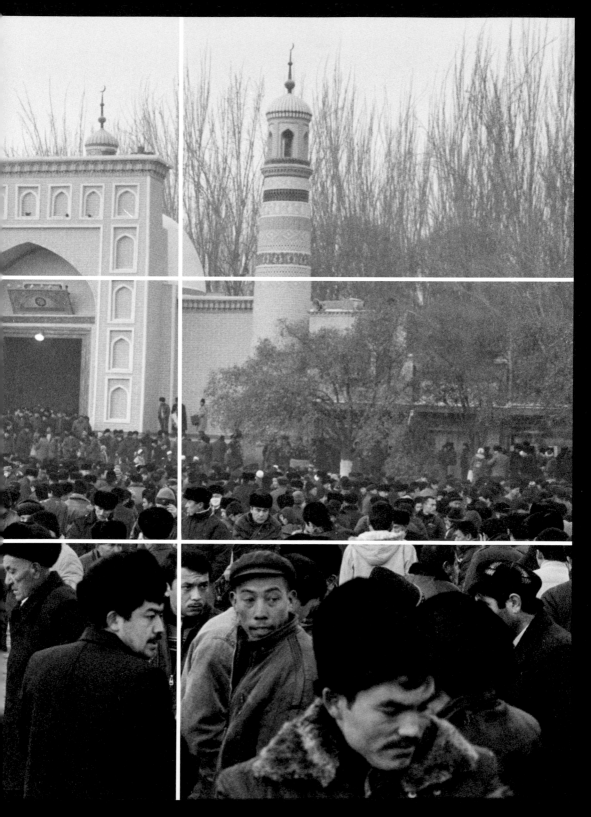

After Friday prayers, the square in front of the Id Kah Mosque in Kashgar is full of men.

THIS PAGE
Behind a boy wearing a traditional Uyghur fur hat, men kneel to pray on the steps of the Id Kah Mosque in Kashgar.

PAGES 56 – 57
MAIN IMAGE Muslim men kneel on prayer mats outside the Id Kah Mosque in Kashgar.

BOTTOM, RIGHT After the prayers and sermons, men dance in the square in front of the Id Kah Mosque to celebrate the start of Eid al-Fitr, the festival that marks the end of Ramadan.

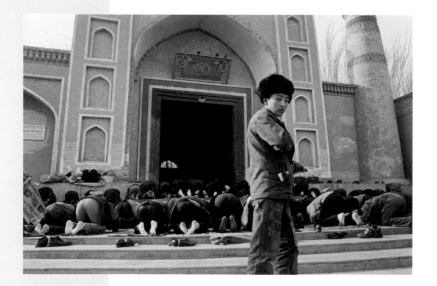

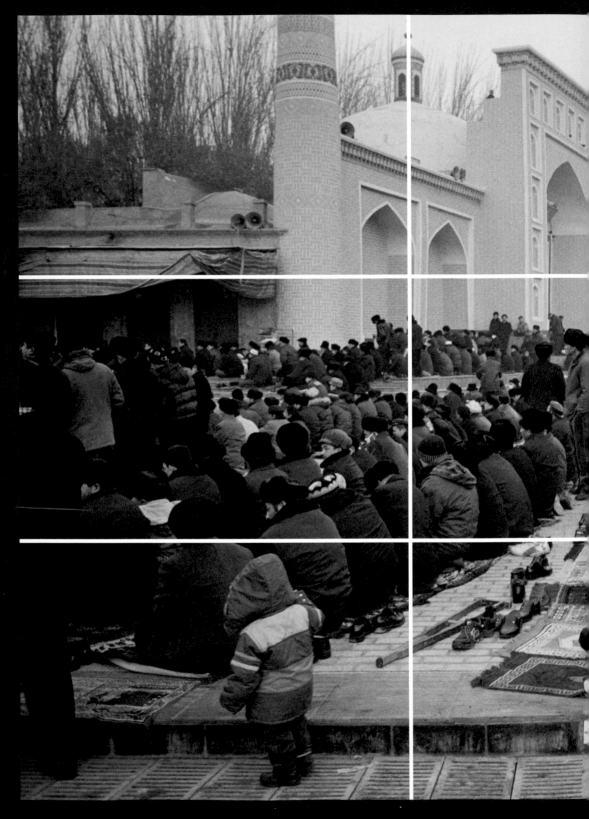

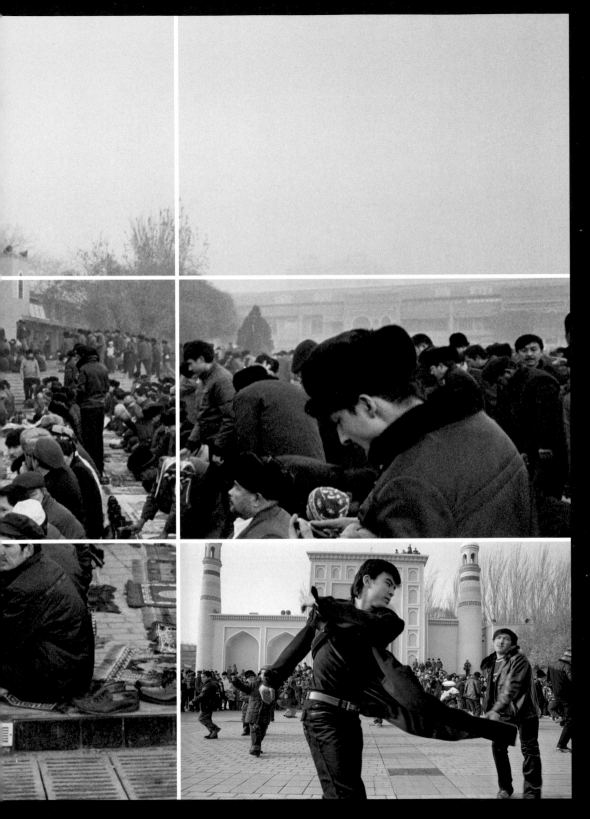

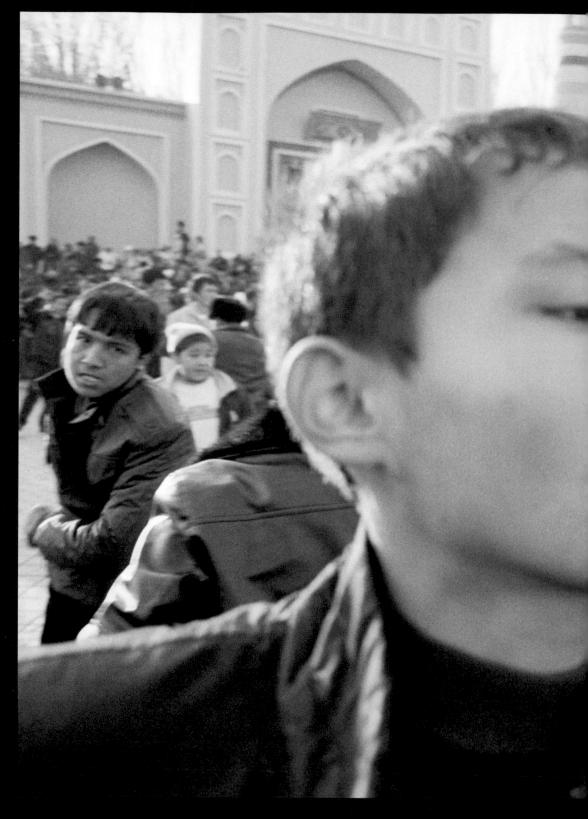

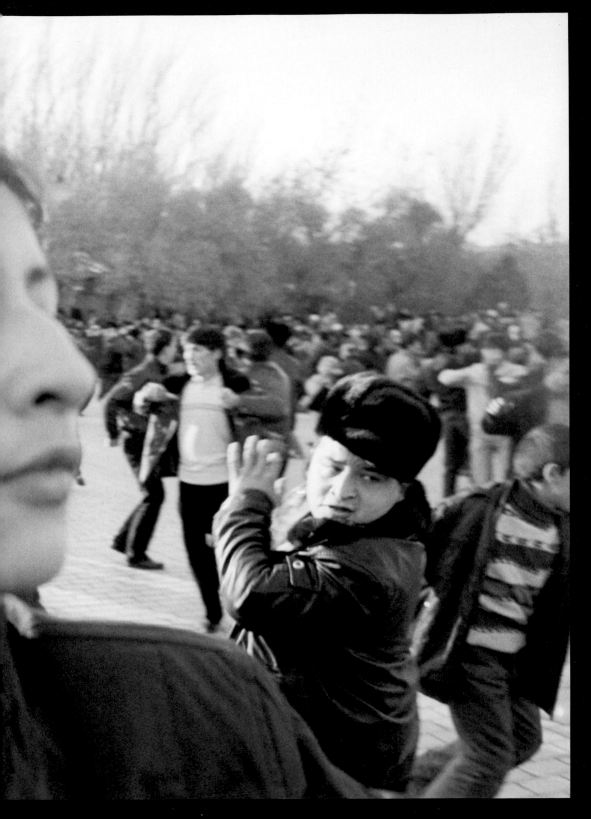

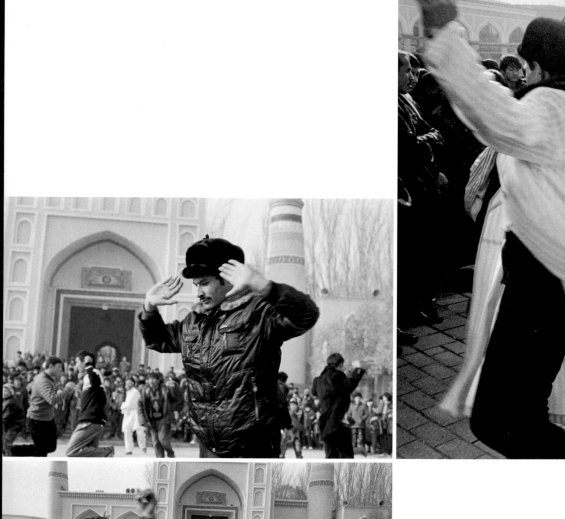

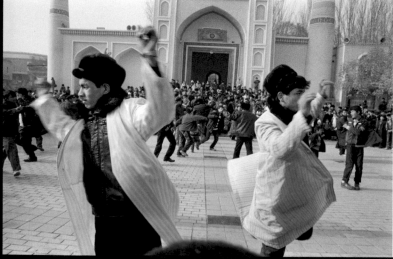

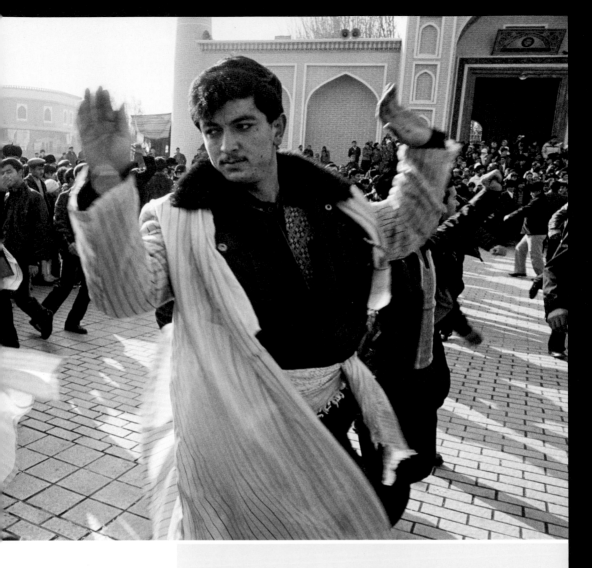

PAGES 58 – 59
The square outside the Id Kah
Mosque continues to fill with
dancers.

THIS PAGE
MAIN IMAGE Uyghur Muslims like
these men must have celebrat-
ed the end of Ramadan by dancing
on this same spot ever since the
original Id Kah Mosque was built
more than 600 years ago.

CENTER, LEFT The men seem
tireless as they swirl and spin in
front of the Id Kah Mosque.

BOTTOM, LEFT Outside the Id Kah
Mosque, there is dancing
throughout the three days of Eid
al-Fitr.

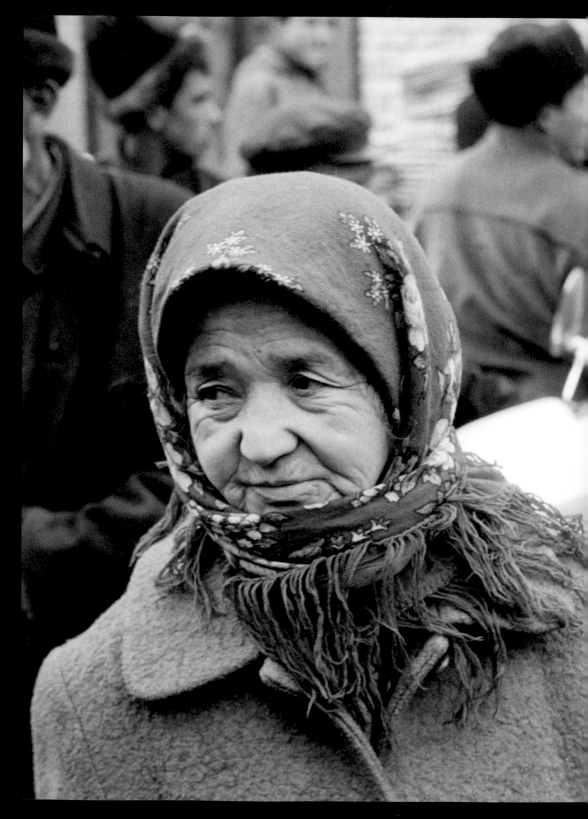

THIS PAGE
A woman walks through a street in
the old part of town in central
Kashgar.

PAGES 64 — 65
An animal trader in the main livestock
market in Kucha.

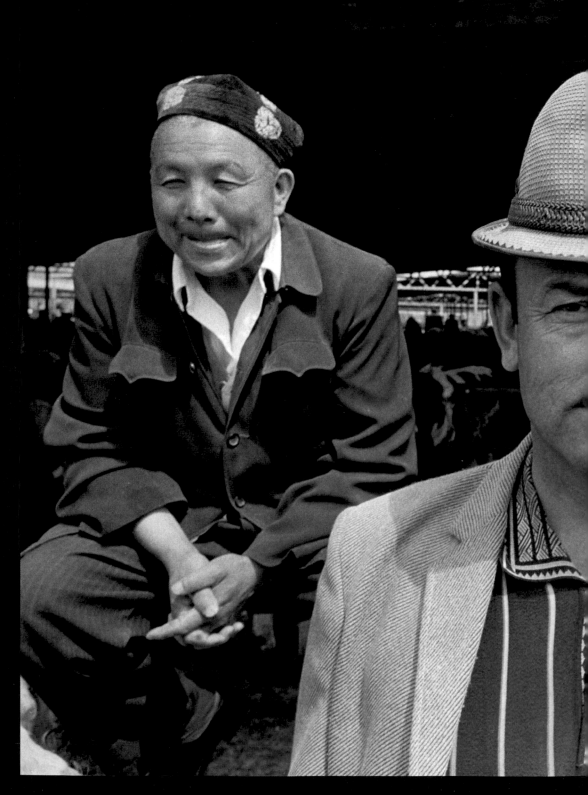

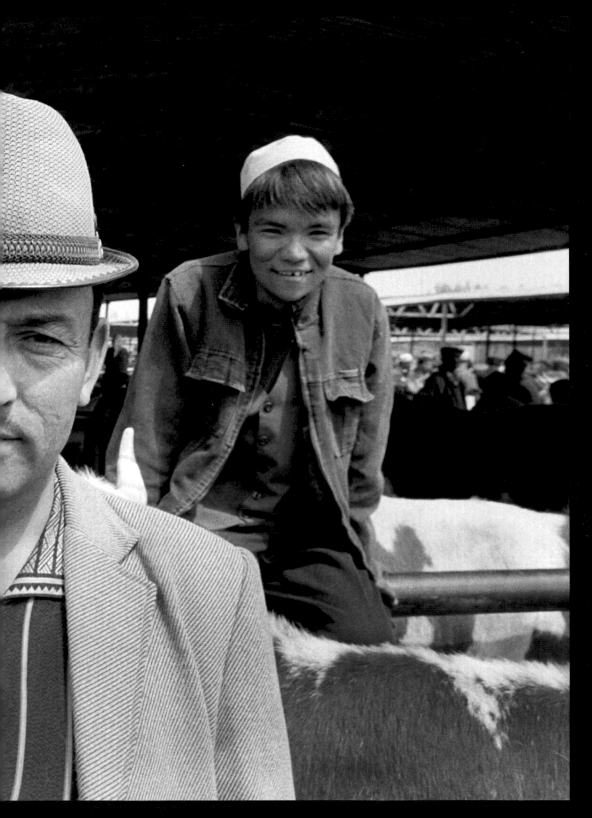

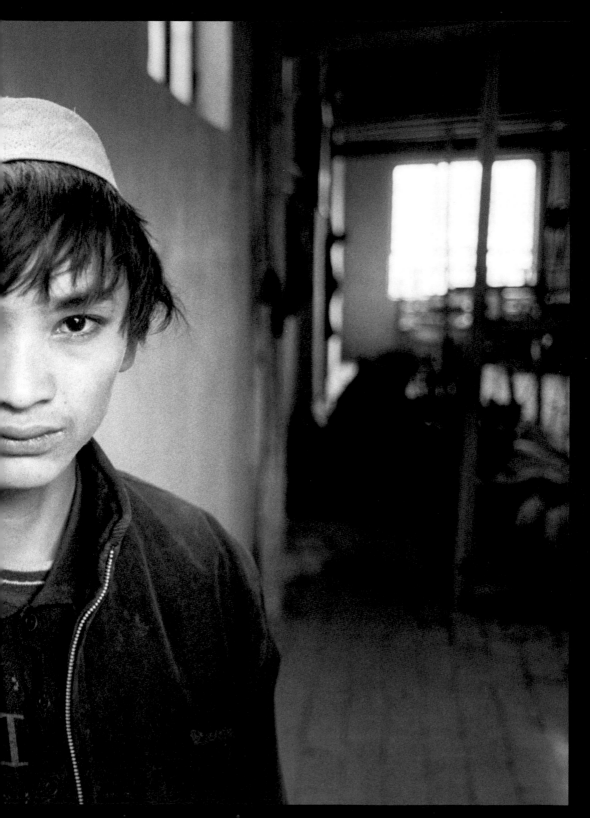

This young boy works on his
family's farm every summer and in
this carpet factory in a village near
Khotan in the winter.

THIS PAGE
Cranes and bulldozers are a
common sight in central Kashgar,
where large-scale urban
reconstruction is taking place.

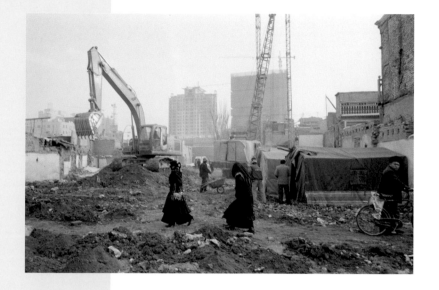

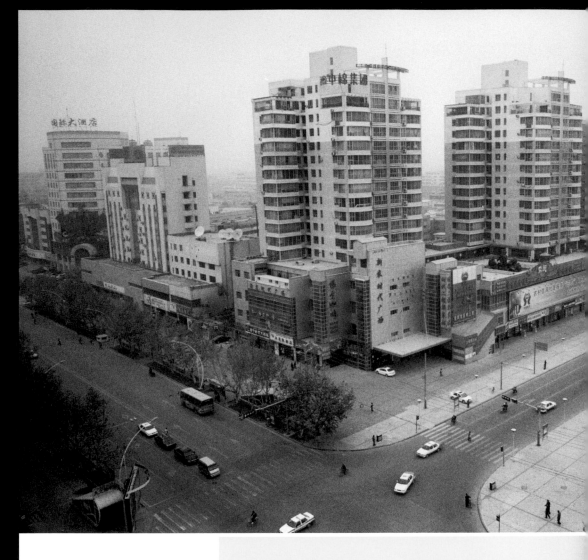

MAIN IMAGE Modern high-rise apartments like these in Aksu are changing cityscapes throughout Xinjiang.

CENTER, RIGHT Many of the houses in the ancient laneways of Kashgar are being torn down. Some will be rebuilt with earthquake-resistant modifications; others will be replaced by modern apartment blocks.

BOTTOM, CENTER Men work to rebuild homes as part of the large-scale reconstruction program taking place in Kashgar.

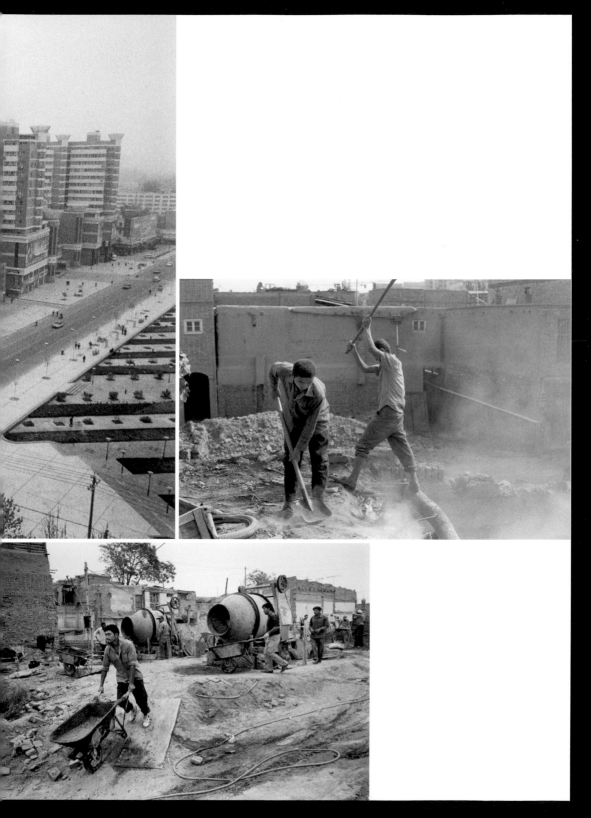

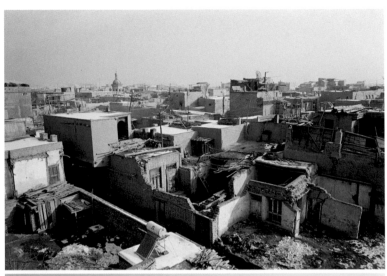

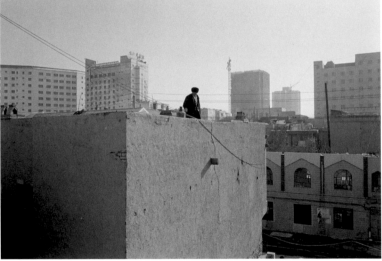

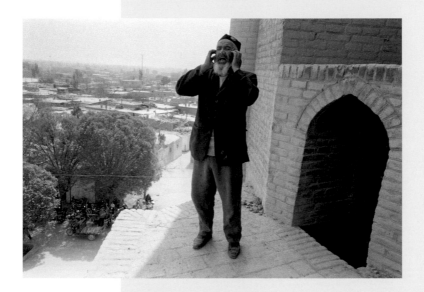

TOP, LEFT Until now, many old
neighborhoods like this one in
Kashgar had remained unchanged
for generations.

BOTTOM, LEFT A man stands on
the rooftop of his house in an old
neighborhood in the center of
Kashgar where new construction is
rapidly encroaching.

RIGHT The call to prayer at the
Grand Mosque in Kucha.

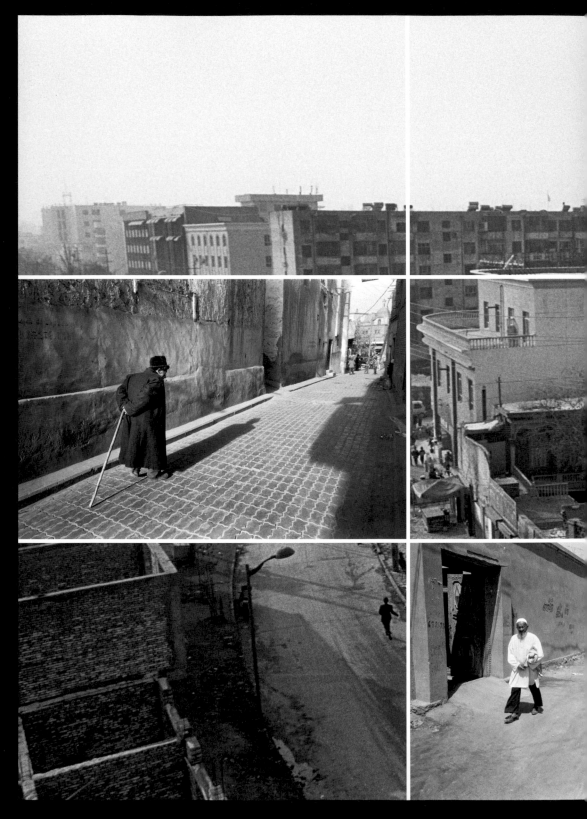

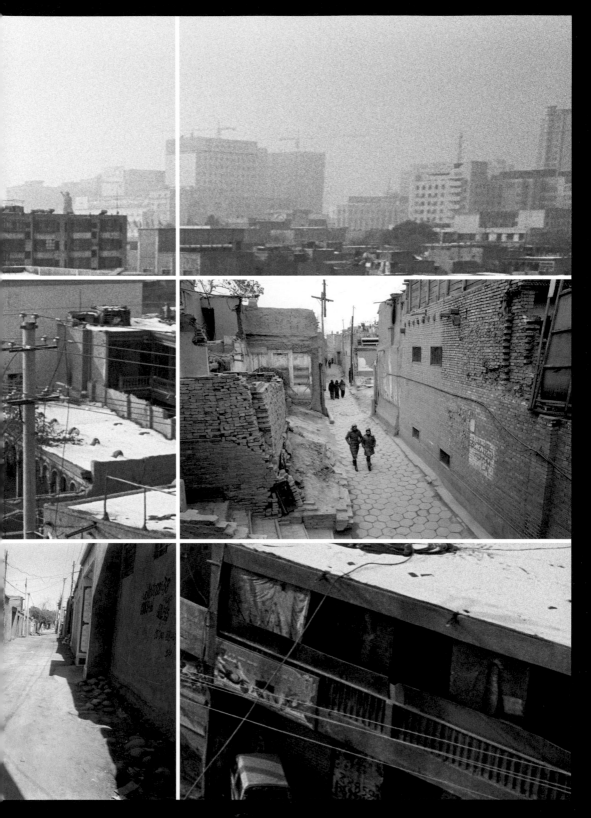

PAGES 74 – 75
MAIN IMAGE The juxtaposition of old and new construction in central Kashgar.

CENTER, LEFT An elderly man walks along a laneway in the old town in Kashgar.

CENTER, RIGHT The old houses lining this laneway in Kashgar are in various stages of demolition and rebuilding.

BOTTOM, CENTER A quiet laneway in the oasis town of Khotan in the Tarim Basin.

THIS PAGE
The Abakh Khoja Tomb, which is in a village near Kashgar, was originally a mausoleum for the father of the famous Islamic leader after whom it's named.

PAGES 78 – 79
MAIN IMAGE A young couple and their child walk along an old laneway in Kashgar.

CENTER, RIGHT In a laneway in Kashgar, a man prepares sheep carcasses for Eid al-Fitr – the Feast of Breaking the Fast.

BOTTOM, RIGHT A man in the old town in Kashgar is watched by his family as he prepares a sheep carcass for the feast to celebrate the end of Ramadan.

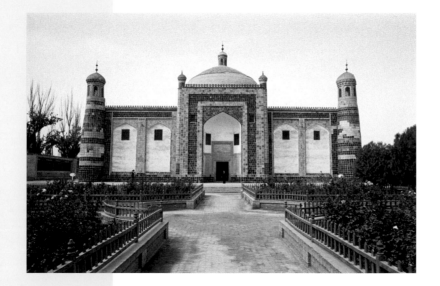

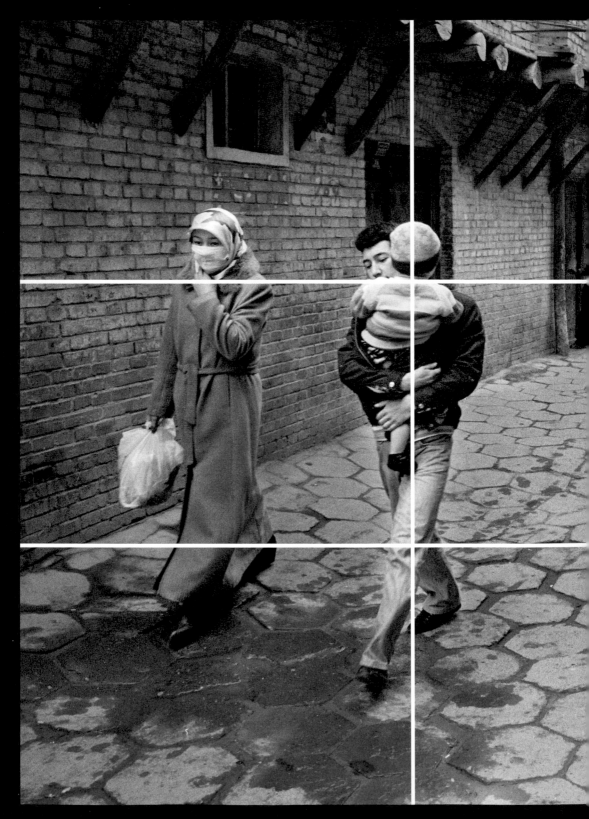

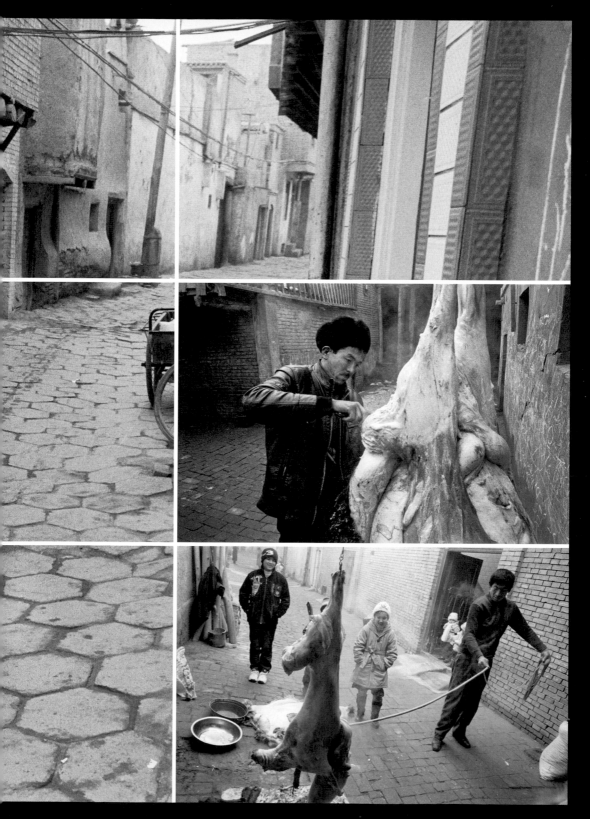

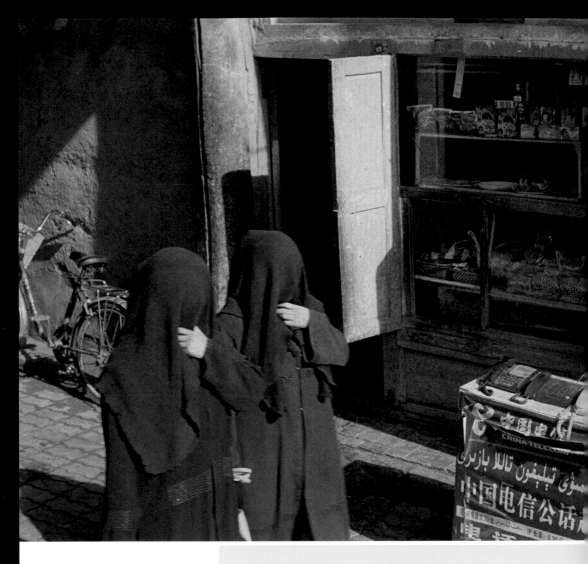

THIS PAGE
MAIN IMAGE Although their faces
are invisible behind full niqab, these
women have a clear view of the
world around them as they walk
along a street in Kashgar.

CENTER, RIGHT Women in
traditional and more modern attire
walk side by side in a laneway in
Kashgar.

BOTTOM, CENTER An elderly
woman walks through a narrow
laneway in central Kashgar.

PAGES 82 — 83
The face of this woman walking
through the streets of Kashgar is
completely covered by a full niqab.

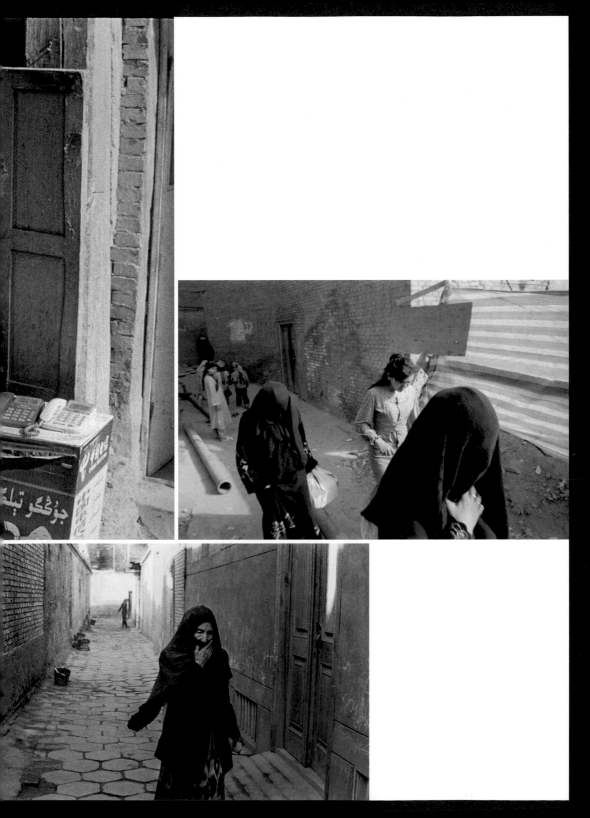

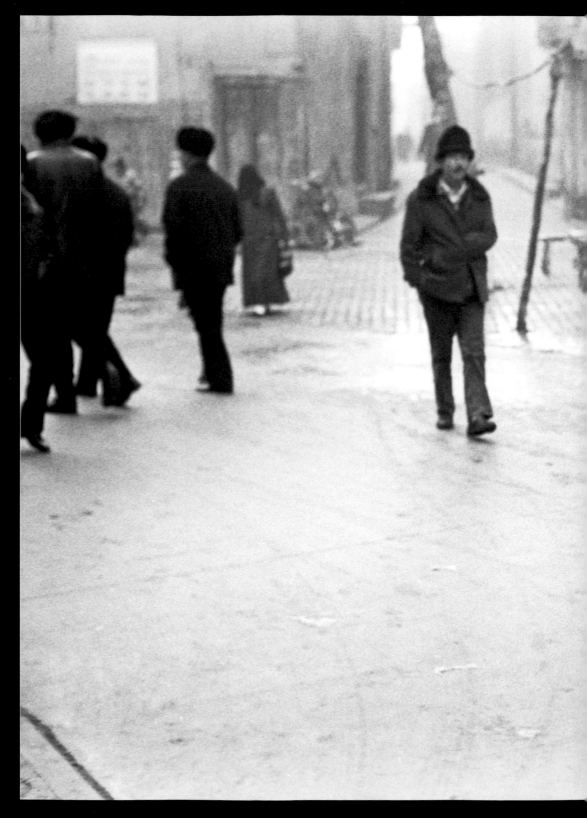

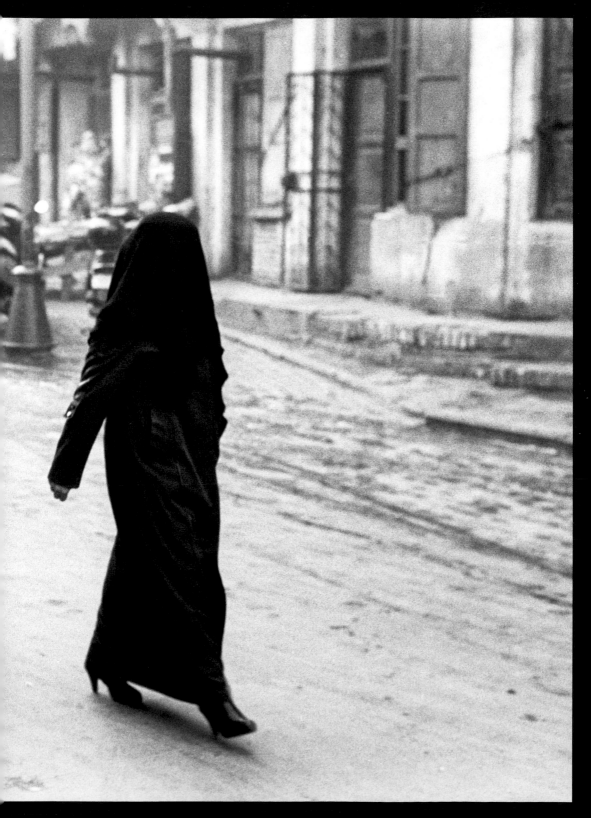

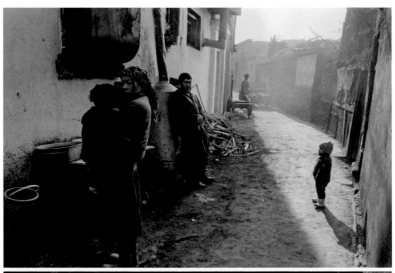

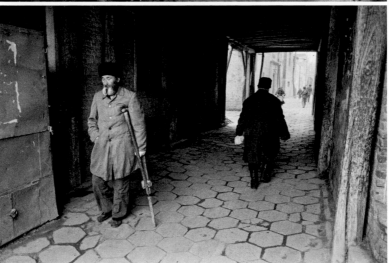

THIS PAGE

TOP, LEFT A young boy warms himself on the sunny side of an old laneway in Khotan.

BOTTOM, LEFT A man supports himself on a wooden crutch as he walks along a laneway in Kashgar.

RIGHT The shadows are just beginning to form in this quiet alleyway in Khotan.

PAGES 86 – 87
A mother and her children stand in the doorway of their home in an old neighborhood in central Kashgar.

PAGES 88 – 89
A young child pushes open the door of his home in the old town of Kashgar. On the other side of the street, the old houses have been replaced by office blocks and garages.

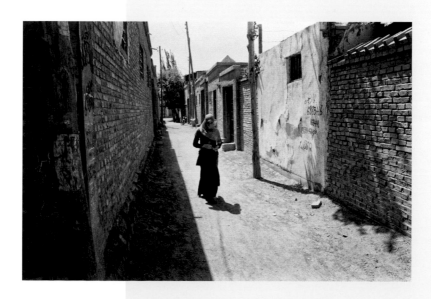

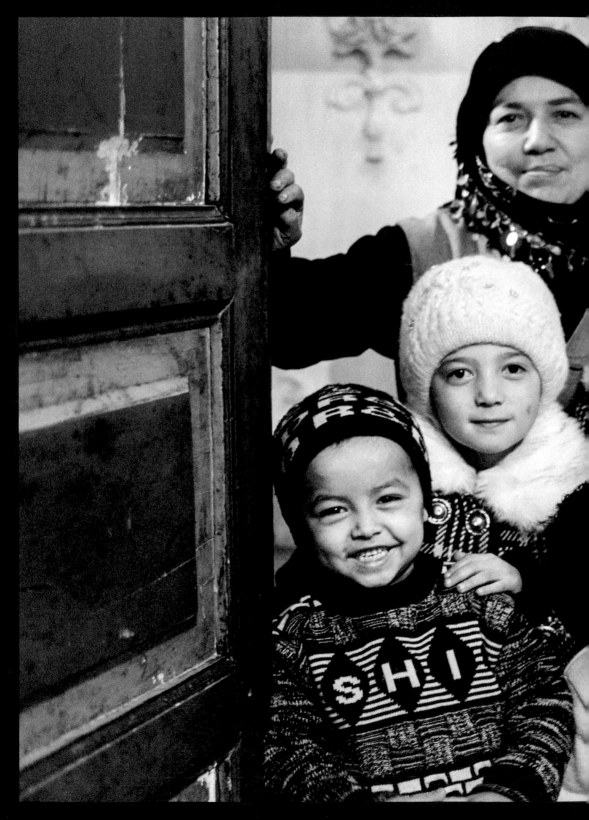

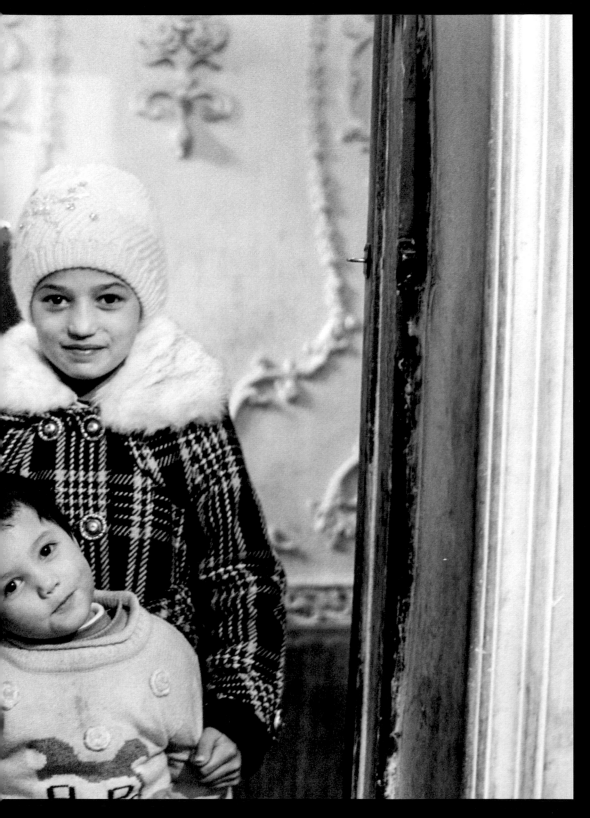

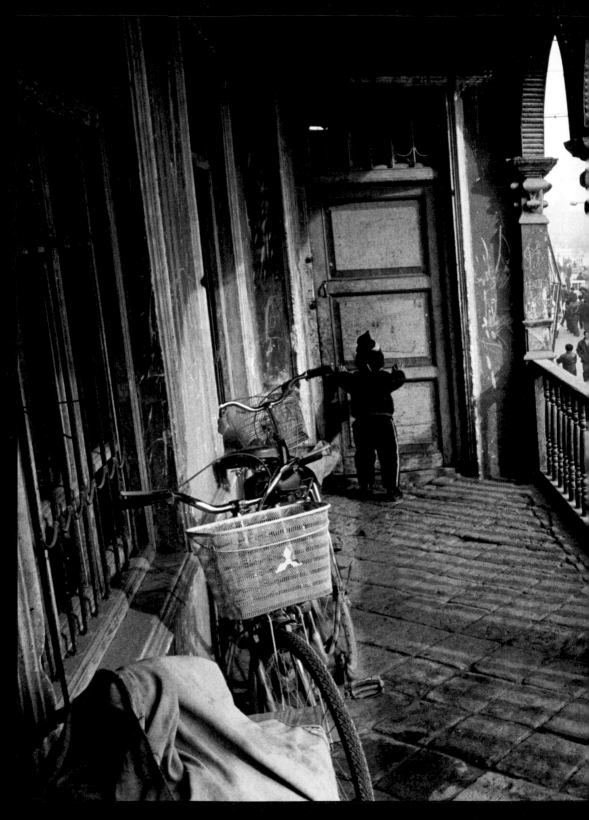

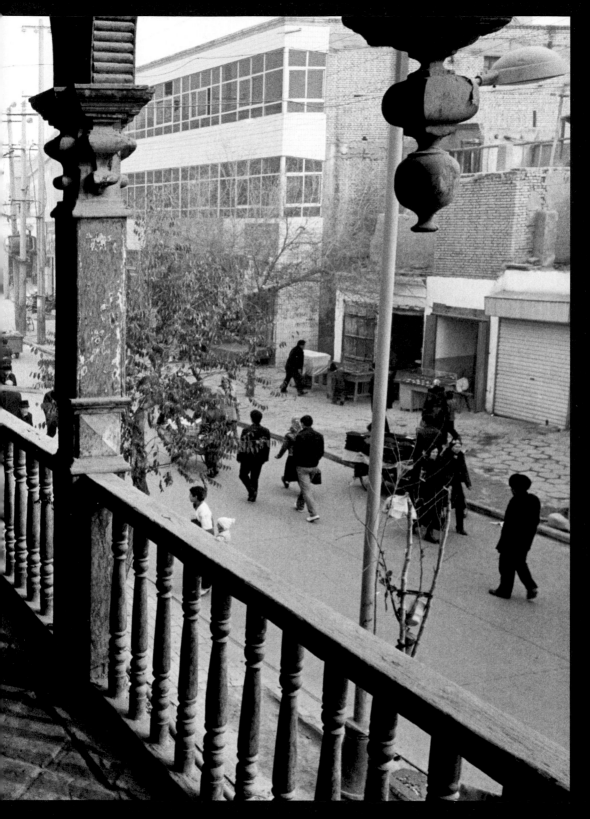

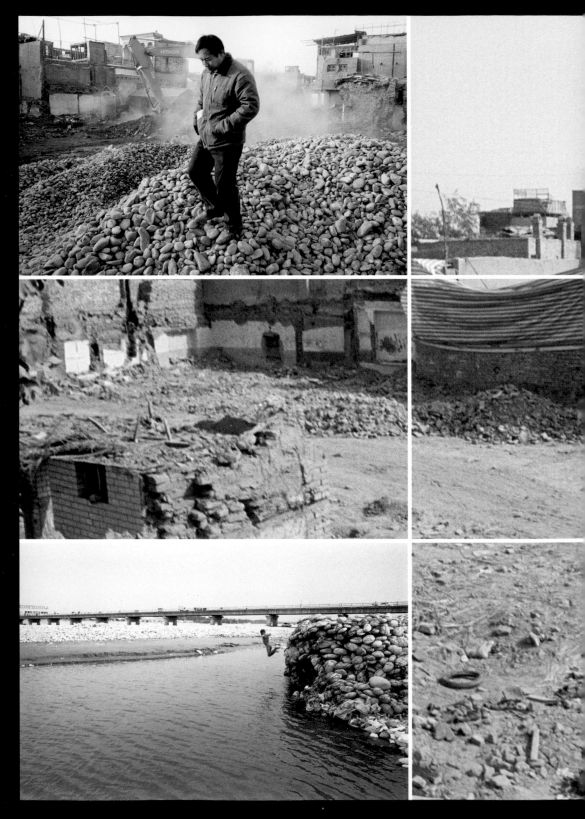

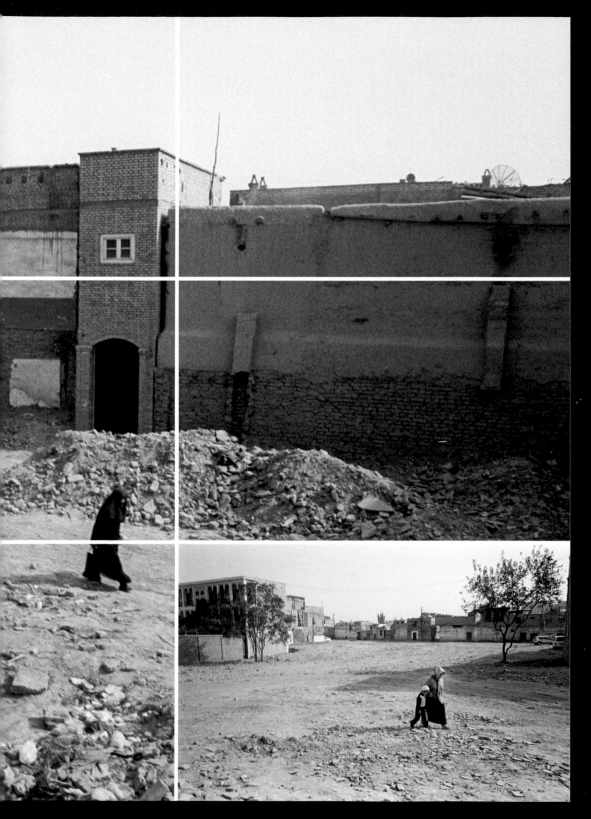

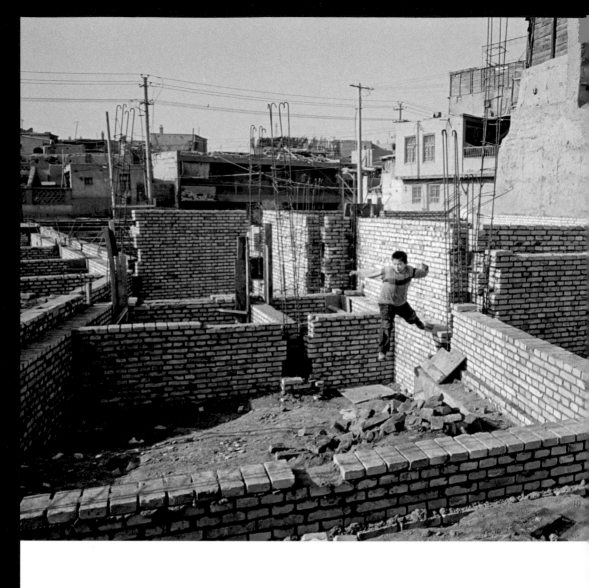

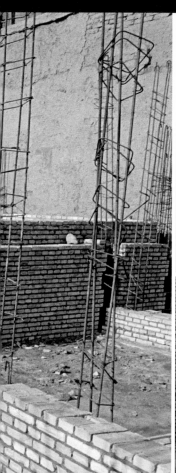

PAGES 90 — 91

MAIN IMAGE A woman walks on a dusty track through what remains of an old neighborhood in central Kashgar where homes have been destroyed as part of the reconstruction efforts.

TOP, LEFT A man clambers over rubble to avoid the dust being raised by cranes and a bulldozer involved in the large-scale urban reconstruction project taking place in central Kashgar.

BOTTOM, LEFT A child jumps off rocks into a stream that feeds into the main Khotan River, which runs through the center of Khotan.

BOTTOM, RIGHT A woman and her son walk through an open space in central Kashgar where houses used to stand.

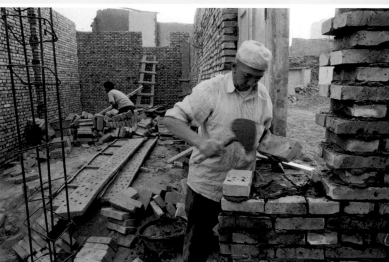

THIS PAGE

MAIN IMAGE A young boy leaps and bounds though a construction site in central Kashgar where old houses are being torn down and rebuilt with steel reinforcement as part of the Chinese government's anti-earthquake measures.

CENTER, RIGHT Construction workers use new bricks to rebuild homes in an old neighborhood of central Kashgar.

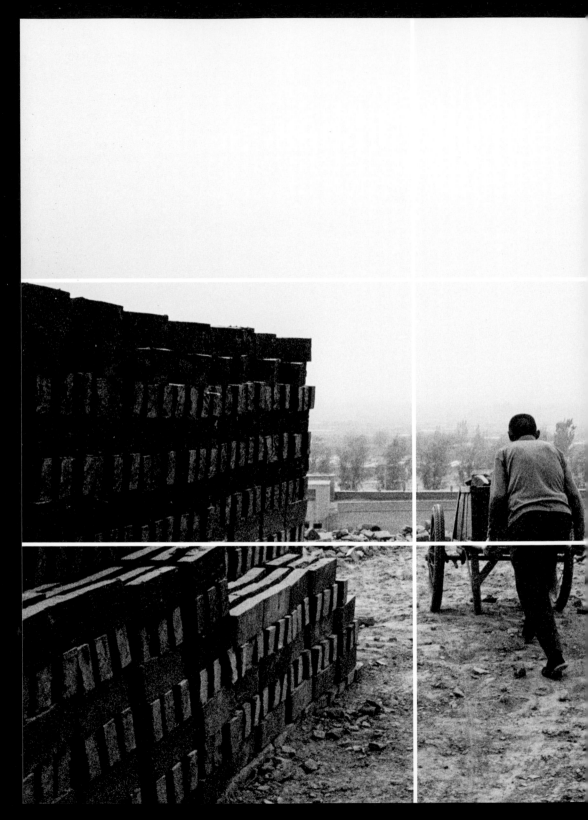

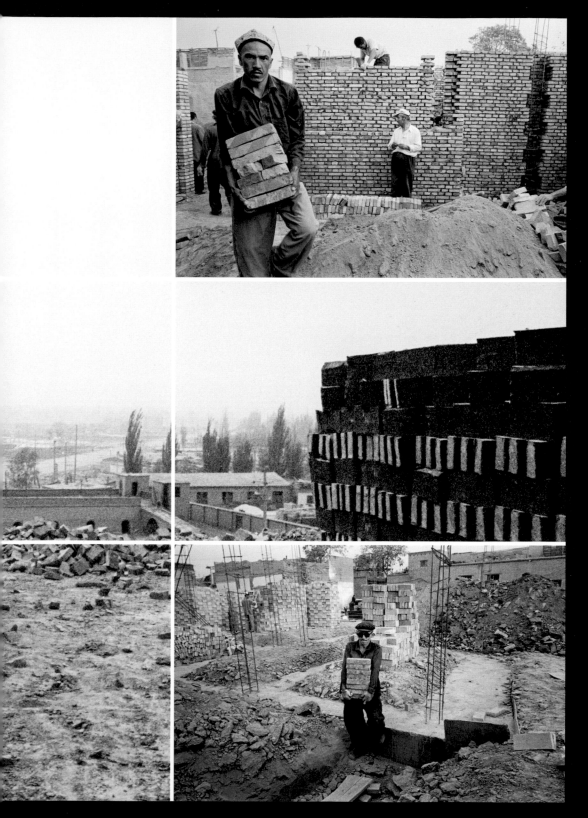

MAIN IMAGE A man pushes a cart of wet bricks at a brick-making factory just outside Kucha.

TOP, RIGHT There are plenty of jobs for construction workers like these men, who are rebuilding homes in central Kashgar.

BOTTOM, RIGHT In this old neighborhood in Kashgar, the houses are being rebuilt around steel props to help resist seismic vibrations.

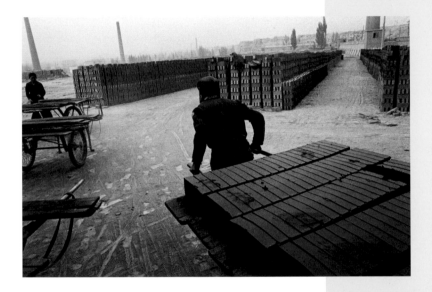

THIS PAGE
LEFT A man pulls a cart loaded with wet bricks at a brick-making factory just outside Kucha.

RIGHT The newly made bricks are stacked in rows to dry.

THIS PAGE
A man working at the brick-making
factory pauses for a moment to
catch his breath.

PAGES 100 — 101
Traders gather in a dry riverbed in
the early morning as they wait for
the main market in Kucha to open.

PAGES 102 — 103
Men walk towards the Id Kah
Mosque for early-morning prayers at
the start of Eid al-Fitr, the festival that
marks the end of Ramadan.

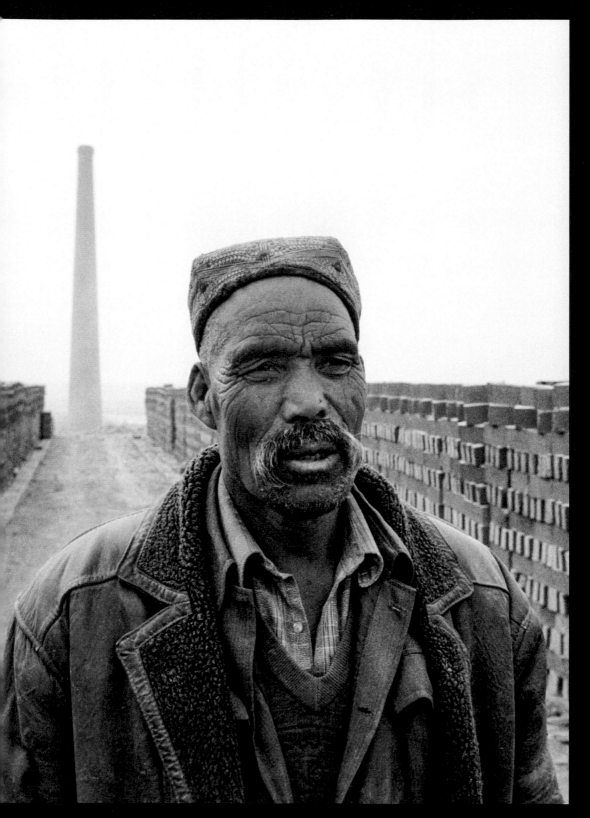

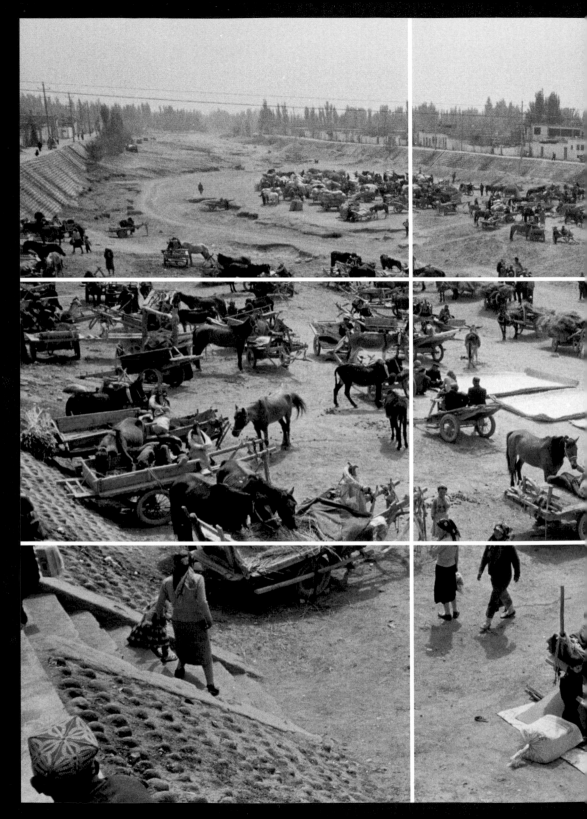

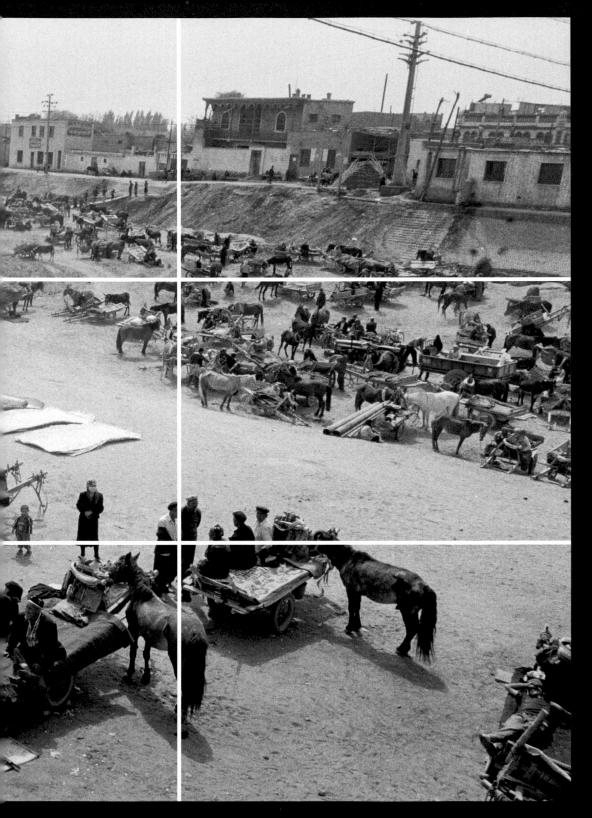

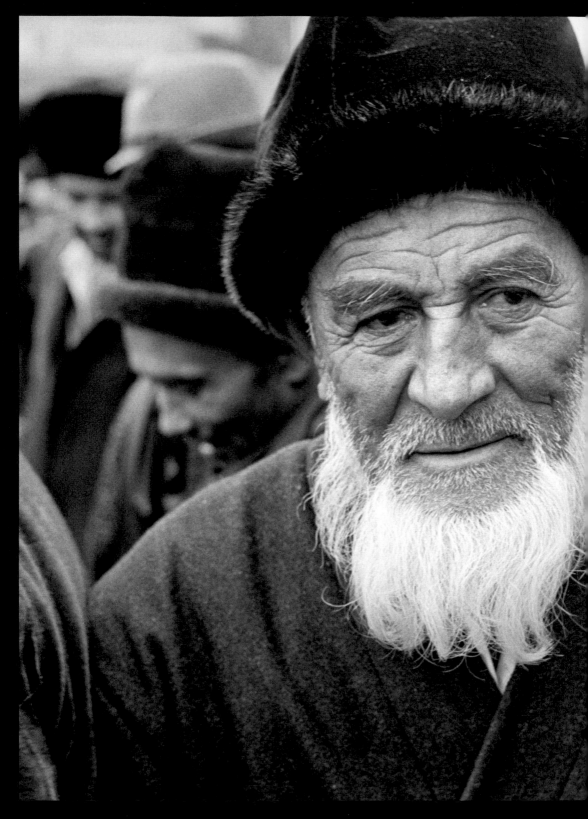

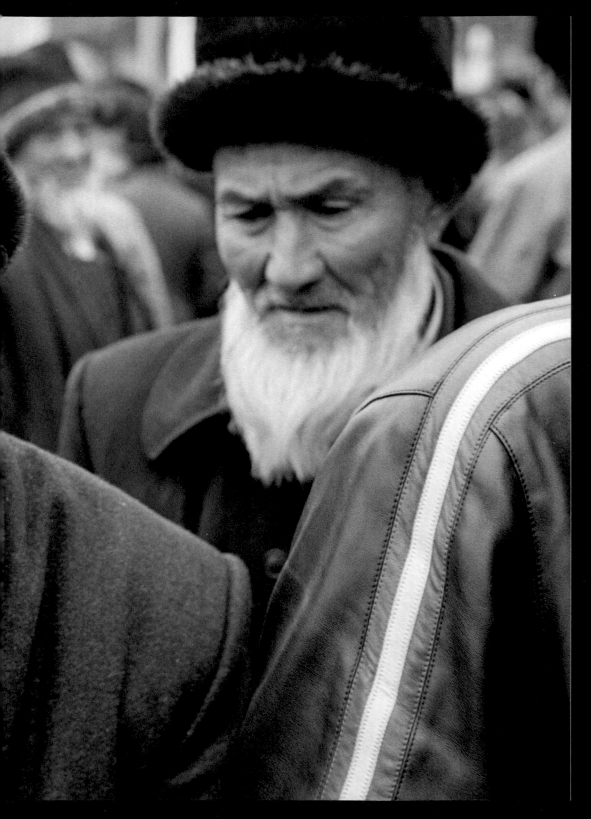

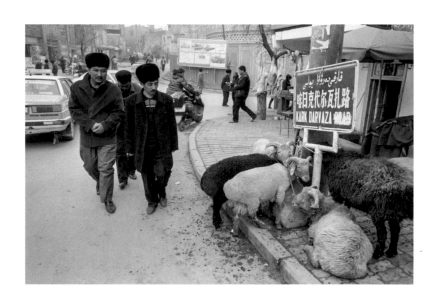

LEFT A street sign becomes a
temporary tethering post for sheep
in an old neighborhood in central
Kashgar.

RIGHT It seems that everyone in
this market in central Kasghar at the
start of Eid al-Fitr is either buying
or selling sheep.

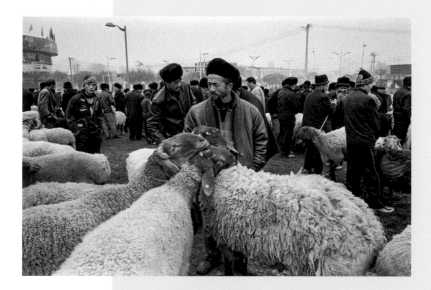

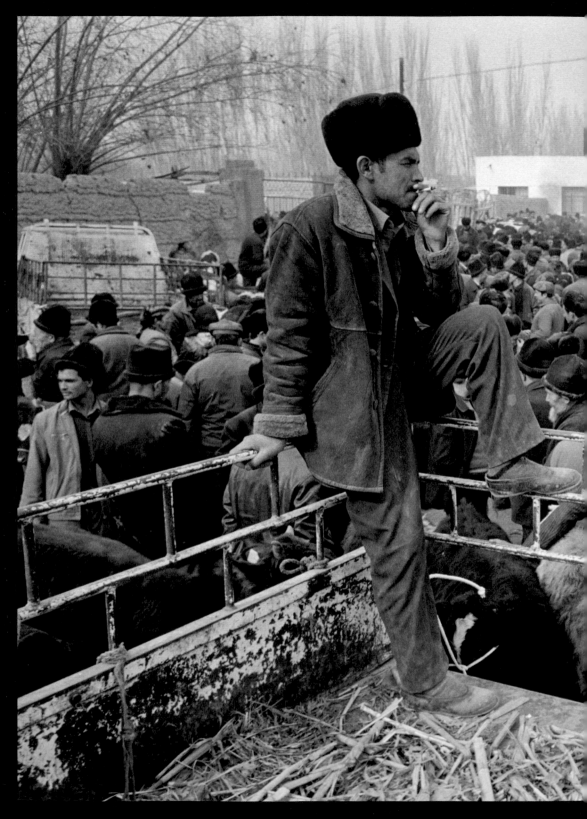

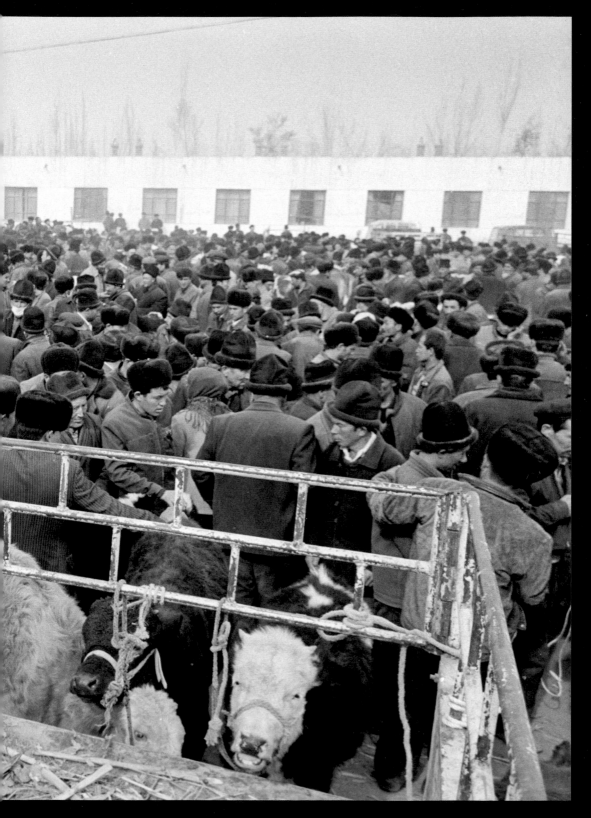

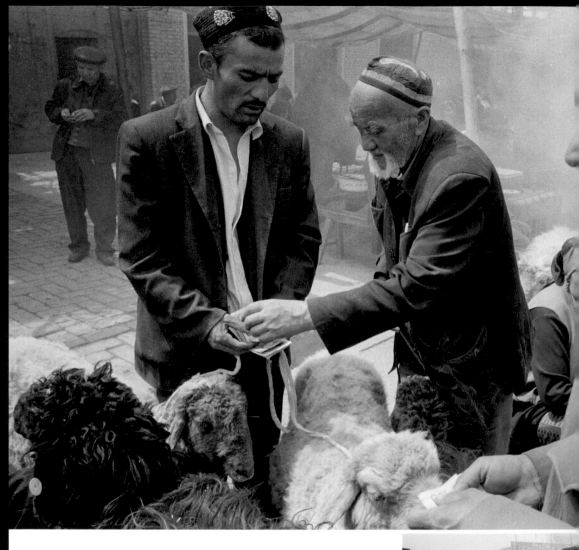

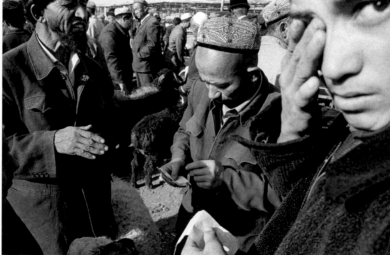

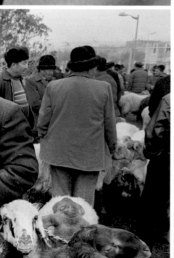

PAGES 106 – 107
A man pauses for a moment to
smoke a cigarette and watch the
crowds that have gathered at a
livestock market in a village on the
outskirts of Kashgar.

THIS PAGE
MAIN IMAGE Deals are struck and
animals are bought and sold at a
livestock market in a remote village
near Kashgar.

CENTER, RIGHT These sheep, being
bought in the market in central
Kashgar, will be slaughtered and
eaten as part of the celebrations to
mark the end of Ramadan.

BOTTOM, CENTER Haggling and
calculations are just part of the
process of buying and selling
livestock in this market in a village
near Kashgar.

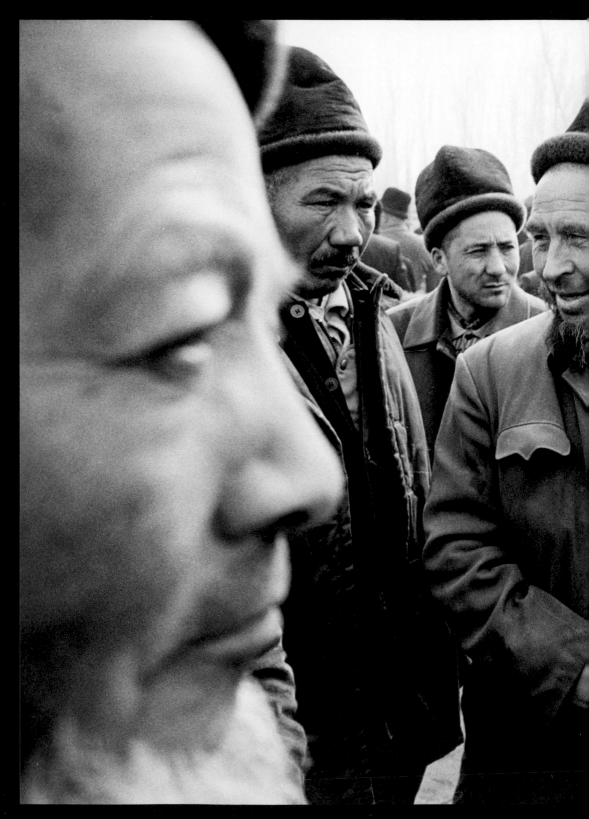

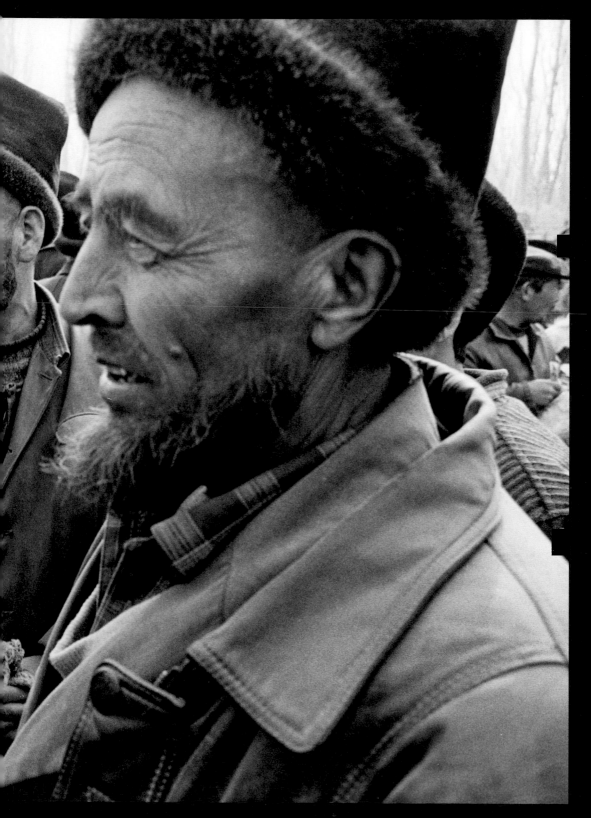

PAGES 110 — 111
Men discuss the prices of donkeys
and sheep at a small livestock
market in a village near Kashgar.

THIS PAGE

MAIN IMAGE Two young boys
unload sheep from a truck at a
Sunday livestock market in Kashgar.

CENTER, LEFT It's a case of either
jump or fall for this cow being
pulled off a truck at a Sunday
livestock market on the outskirts of
Kashgar.

BOTTOM, LEFT Sheep are
unceremoniously offloaded from a
truck at a Sunday livestock market
in a suburb of Kashgar.

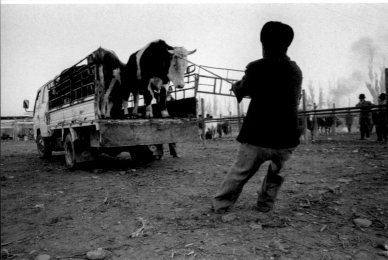

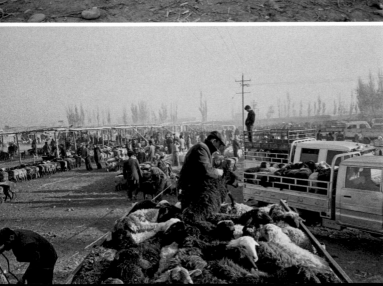

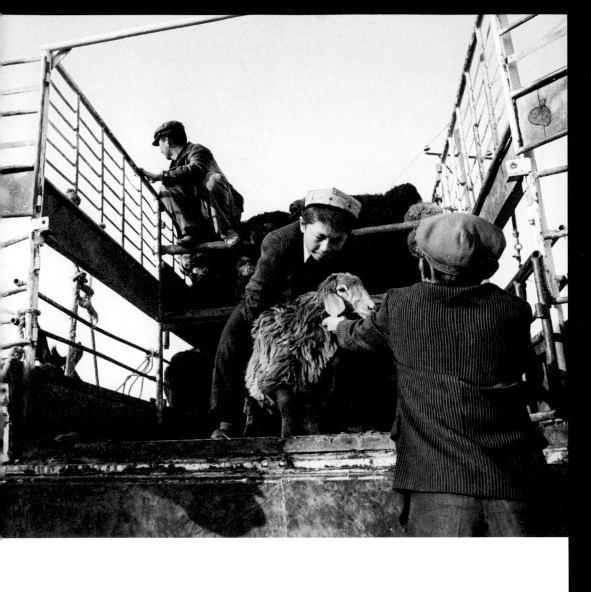

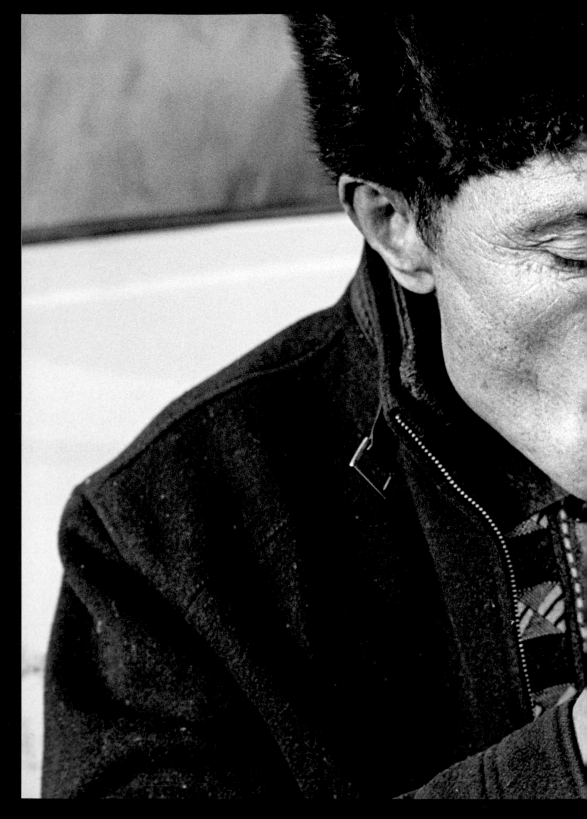

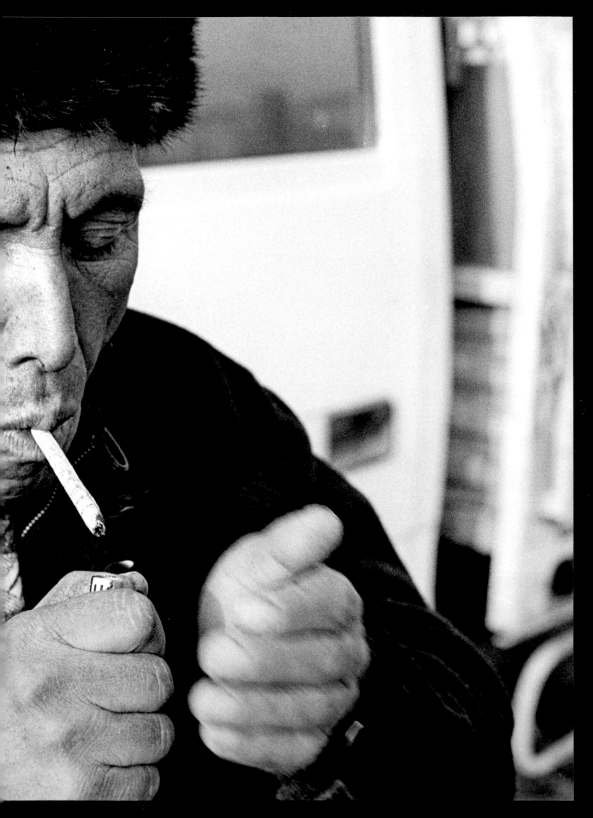

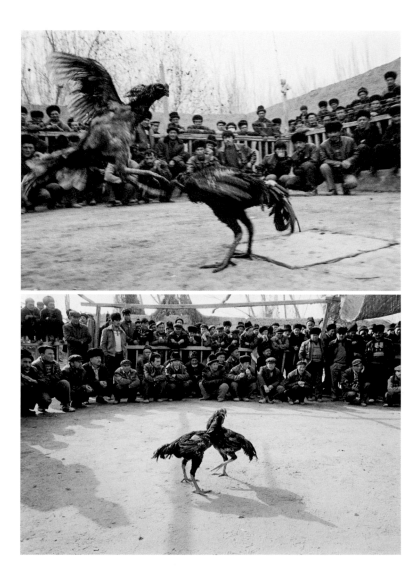

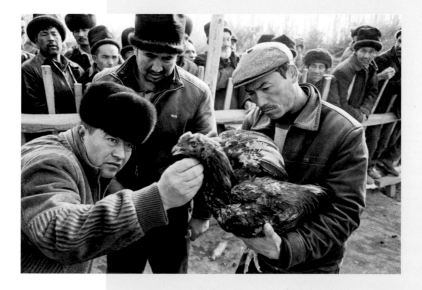

PAGES 114 – 115
A man lights a postprandial cigarette at a restaurant in a village near Kashgar.

THIS PAGE
TOP, LEFT Cock fighting is a popular local tradition in Xinjiang; this competition was taking place on market day in a village near Kashgar.

BOTTOM, LEFT As the cocks begin to tire, the attention of the crowd is momentarily distracted. This competition was taking place on market day in a village on the outskirts of Kashgar.

RIGHT A man inspects a bird before it enters the ring to fight.

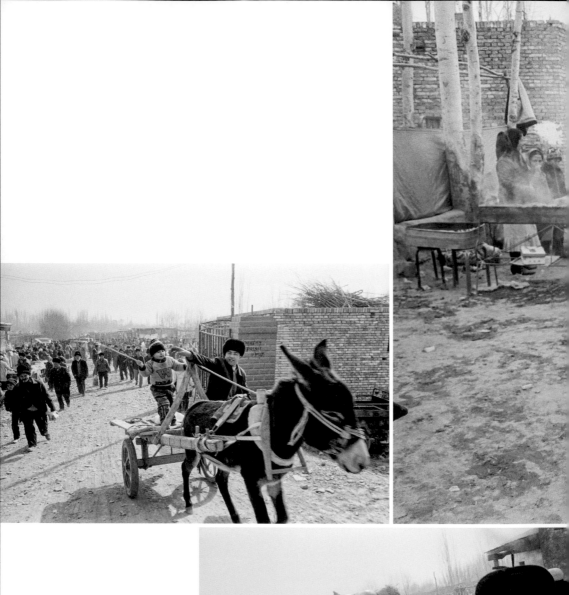
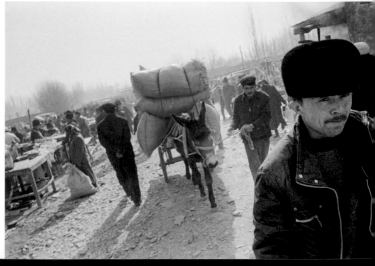

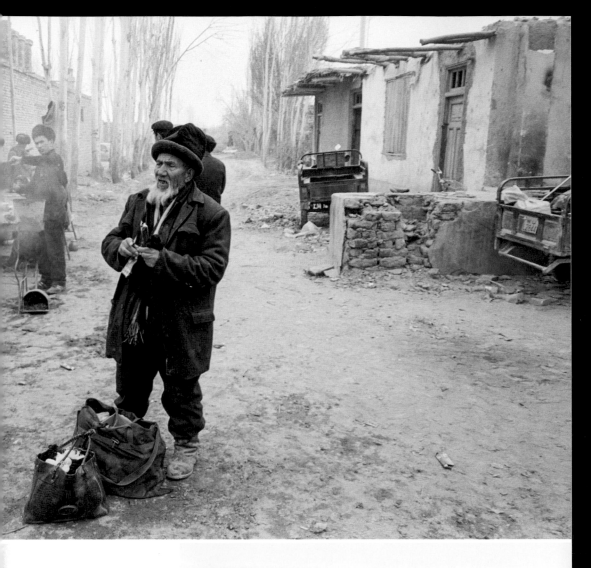

THIS PAGE
MAIN IMAGE An elderly man begs for money in a market in a village near Kashgar.

CENTER, LEFT In a village near Kashgar, a man and a young boy leave the crowded market on their donkey cart.

BOTTOM, CENTER A man steers a heavily laden donkey cart through a village market near Kashgar.

PAGES 120 – 121
Try before you buy: a man test-rides a horse at a livestock market in a village near Kashgar.

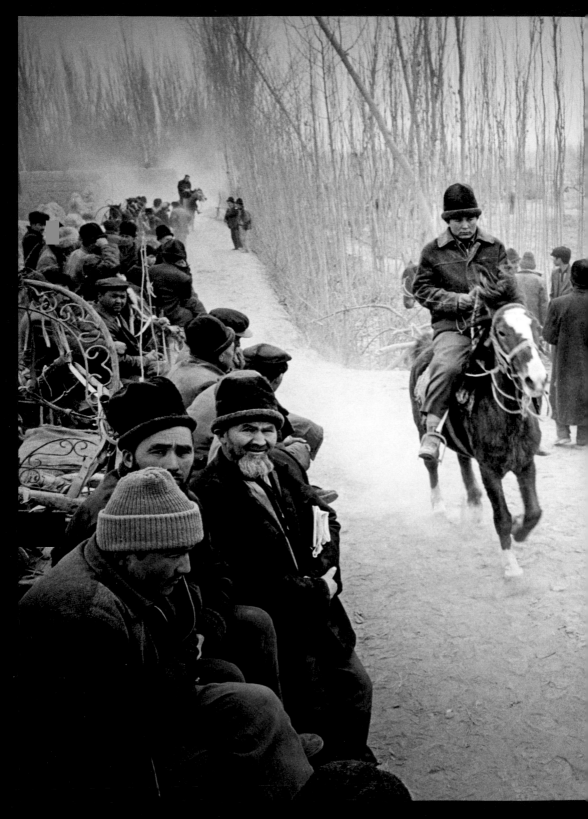

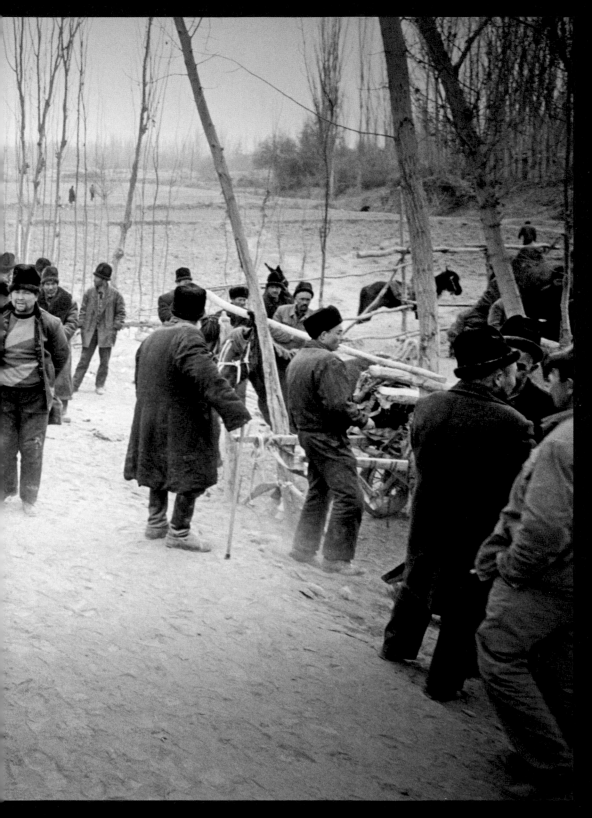

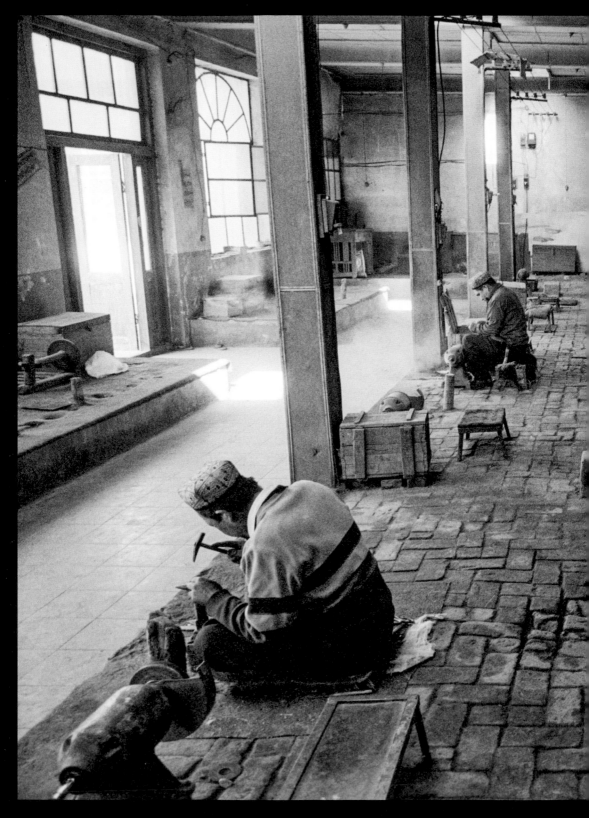

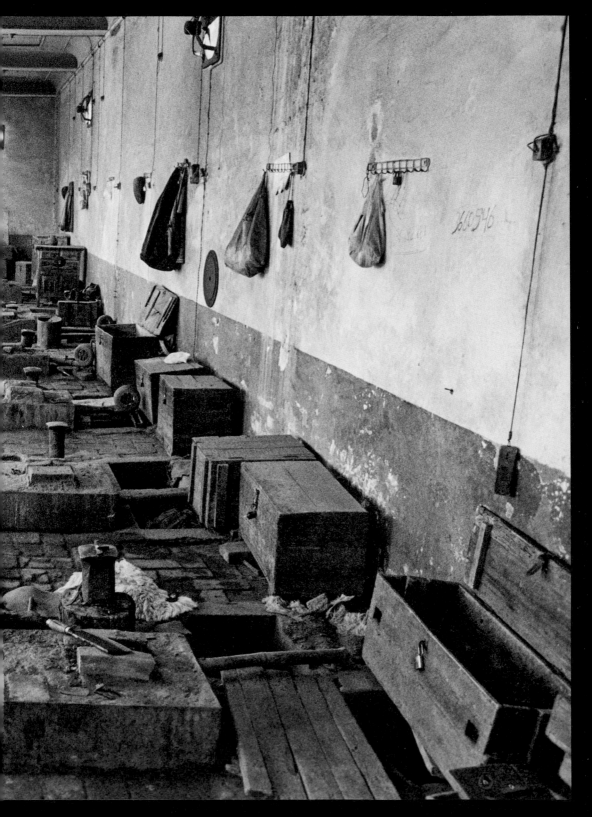

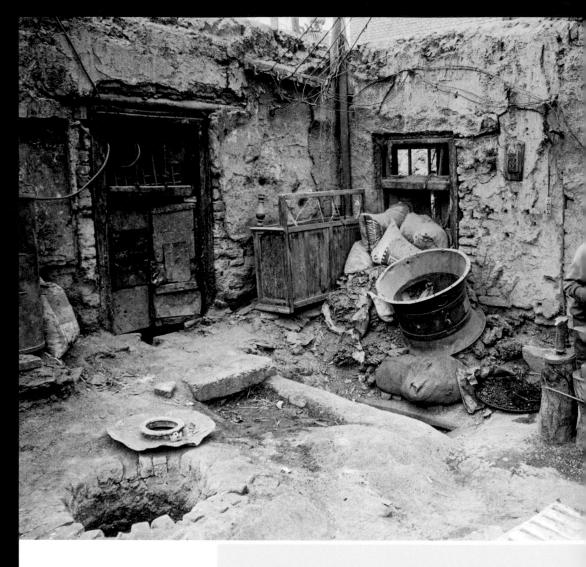

PAGES 122 – 123
These men are working in a
knife-making factory in a village
near the town of Yengisar, which is
renowned for its traditional Uyghur
knives.

THIS PAGE
MAIN IMAGE An elderly blacksmith
works alone in a corner of the
blacksmiths' market in central
Kashgar.

CENTER, RIGHT A young woman
weaves a carpet in a village near
Khotan.

BOTTOM, RIGHT A woman uses a
traditional wooden loom to weave a
carpet in a carpet factory in a small
farming village on the outskirts of
Khotan.

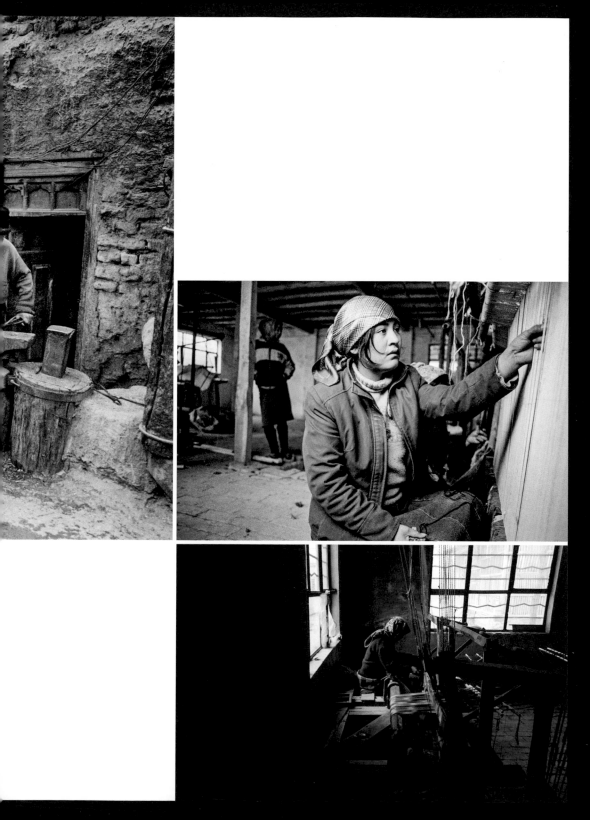

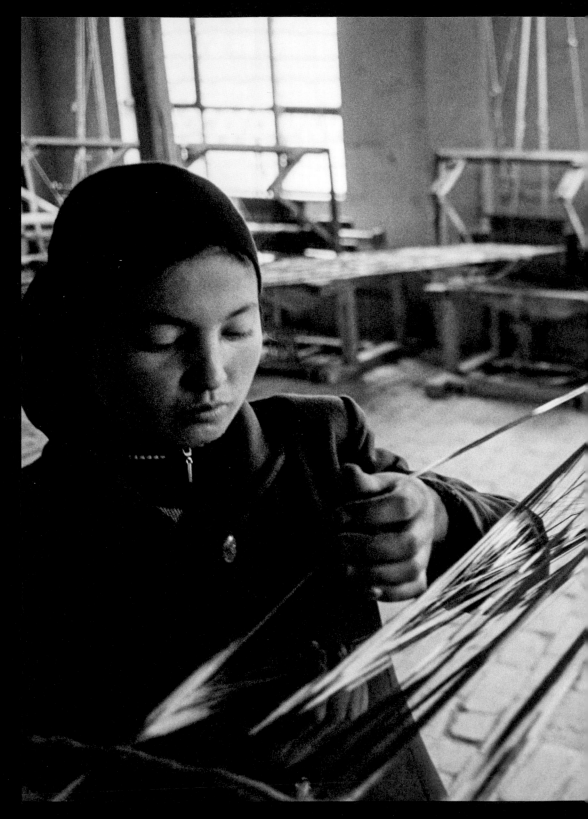

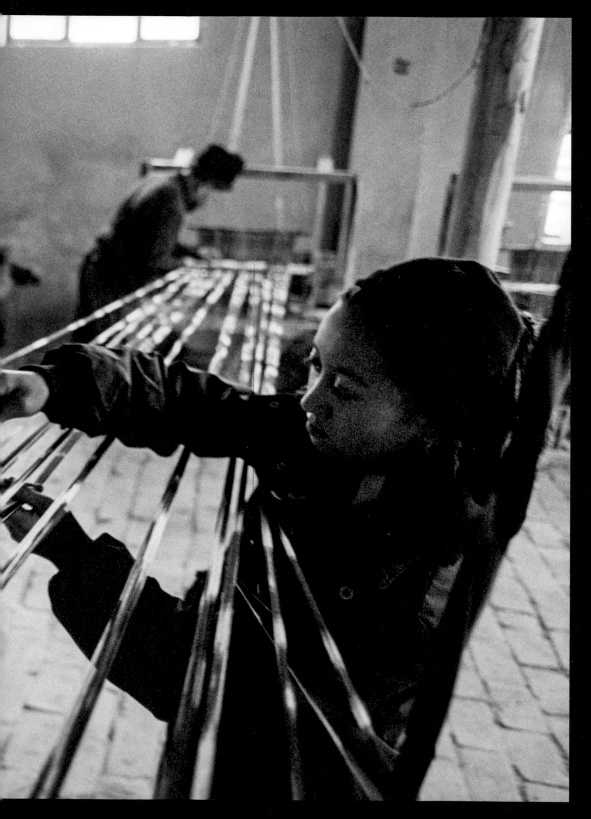

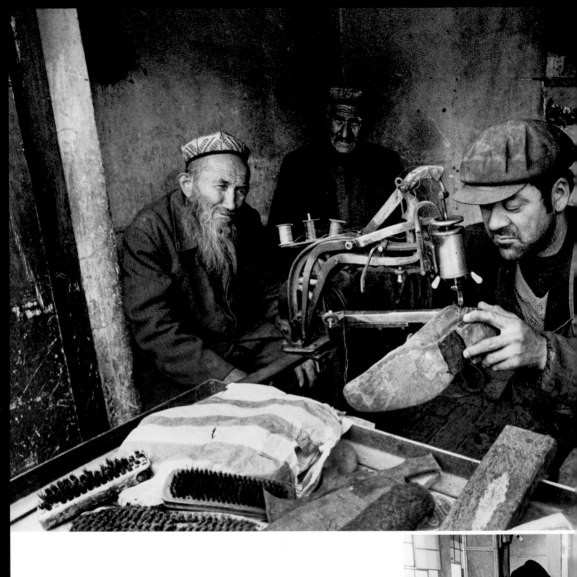

PAGES 126 – 127
Two young girls at work in a carpet factory in a village near Khotan.

THIS PAGE
MAIN IMAGE An old man waits while a shoe repairer mends his shoes at a small shop in an old neighborhood in Kucha.

BOTTOM, CENTER A retired knife maker has returned to a knife factory in a village near Yengisar to watch his son work.

BOTTOM, RIGHT A young black-smith sharpens farming tools at the blacksmiths' market in central Kashgar.

PAGES 130 – 131
Young men make knives in their home in a village in Yengisar County.

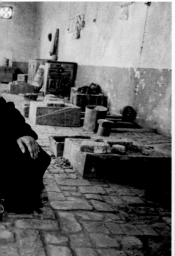

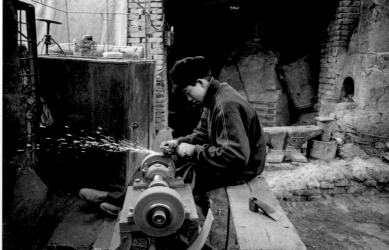

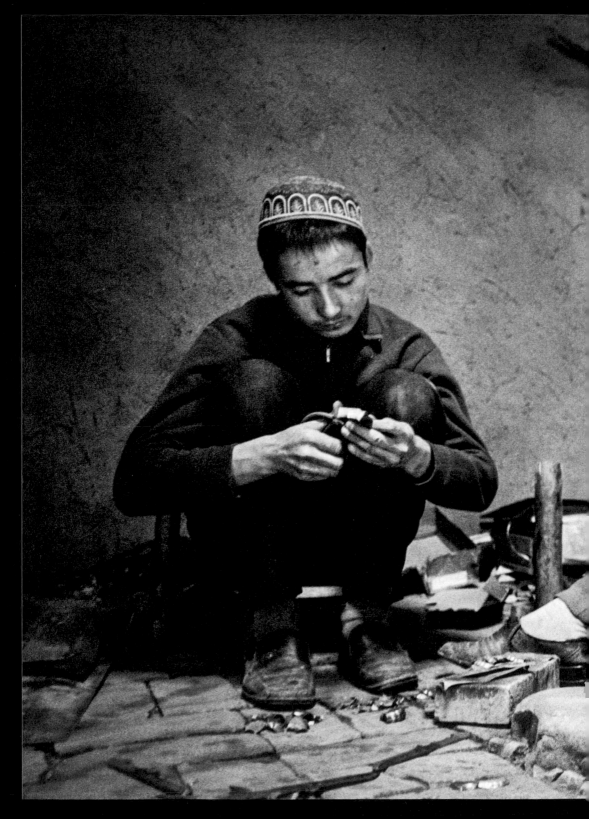

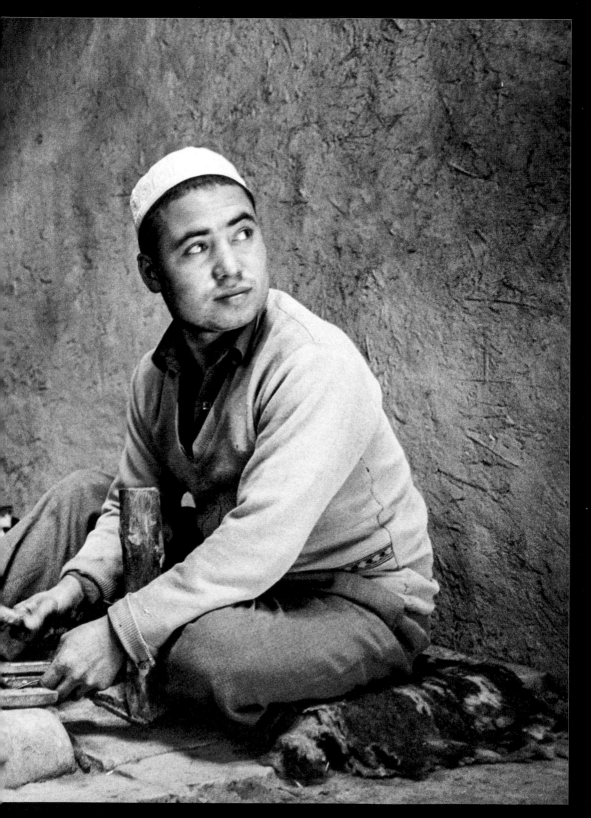

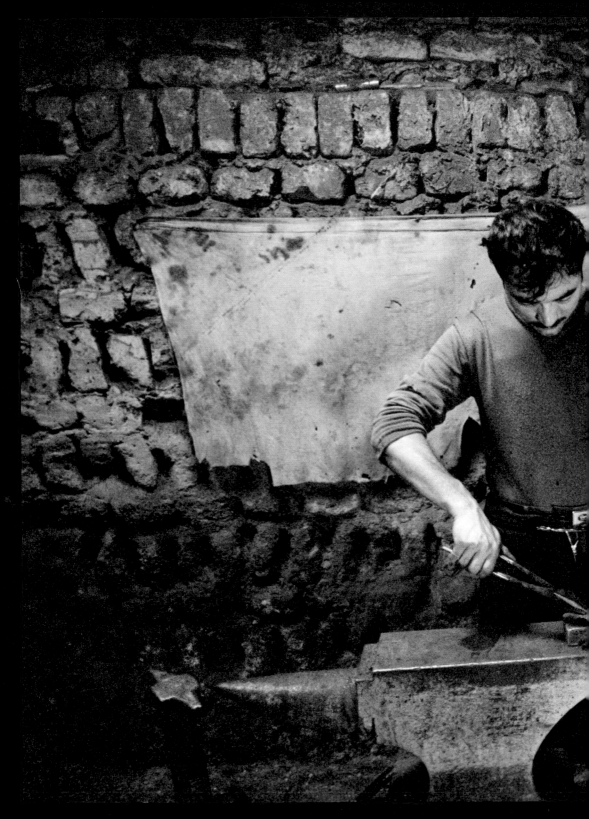

PAGES 132 – 133
A blacksmith beats hot metal into
shape on the anvil in his workshop in
Kasghar.

THIS PAGE
A man warms himself by the stove in
a restaurant in Bayan Bulak, a small
grassland village at the foot of the
Tian Shan mountain range.

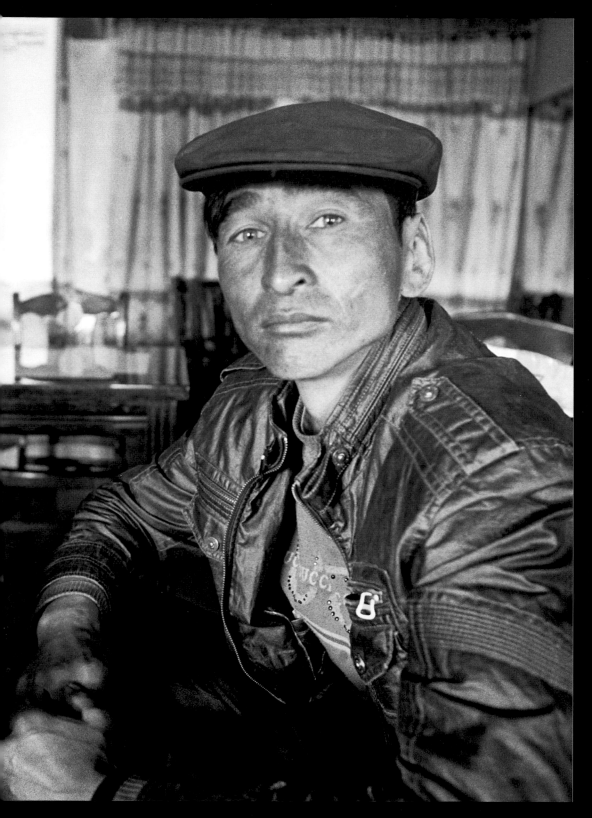

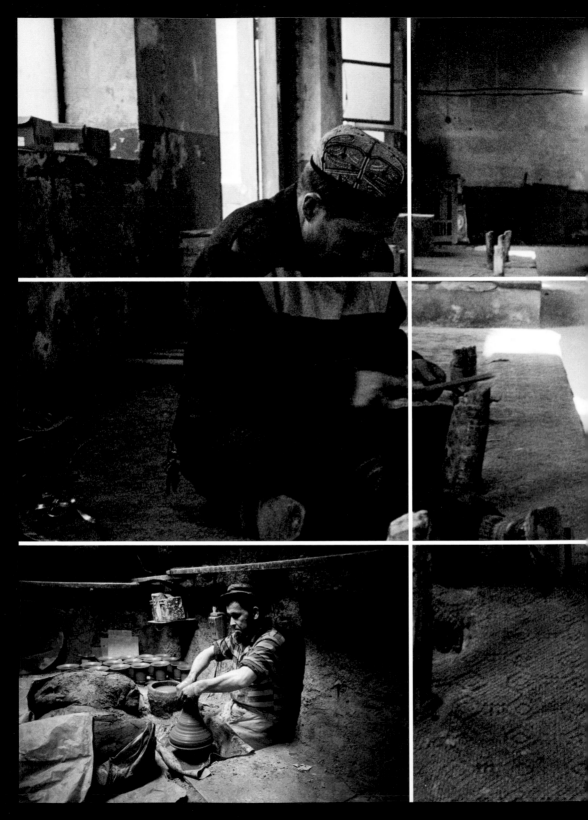

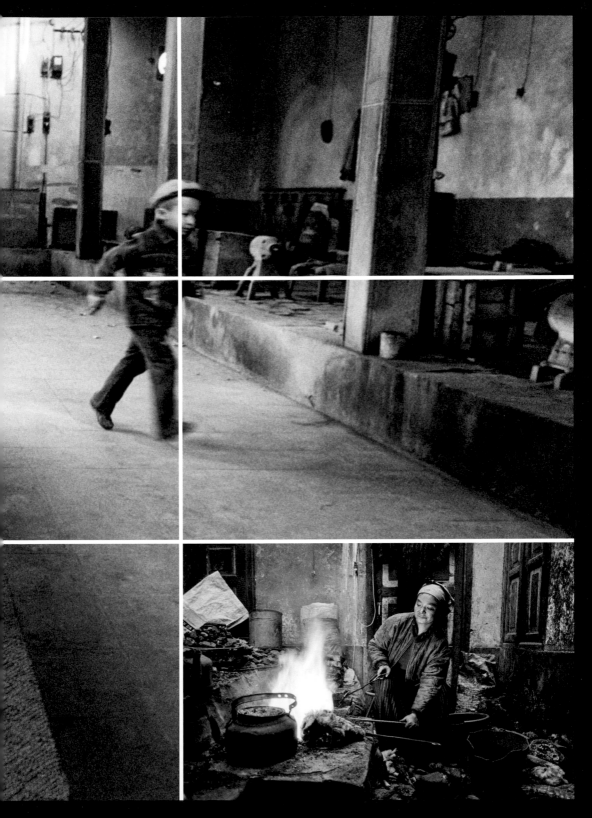

PAGES 136 – 137
MAIN IMAGE A young child runs
through a knife-making factory in a
village near the town Yengisar.

BOTTOM, LEFT A man sculpts
traditional clay vases in his home in
central, Kashgar.

BOTTOM, RIGHT This woman is
burning the wool and skin off
sheep's heads in her home in central
Kashgar. Every part of a sheep can
be eaten, from the fat in its tail to
the meat on its head.

THIS PAGE
An old man takes a break from
making knives in his home in a
village near Yengisar.

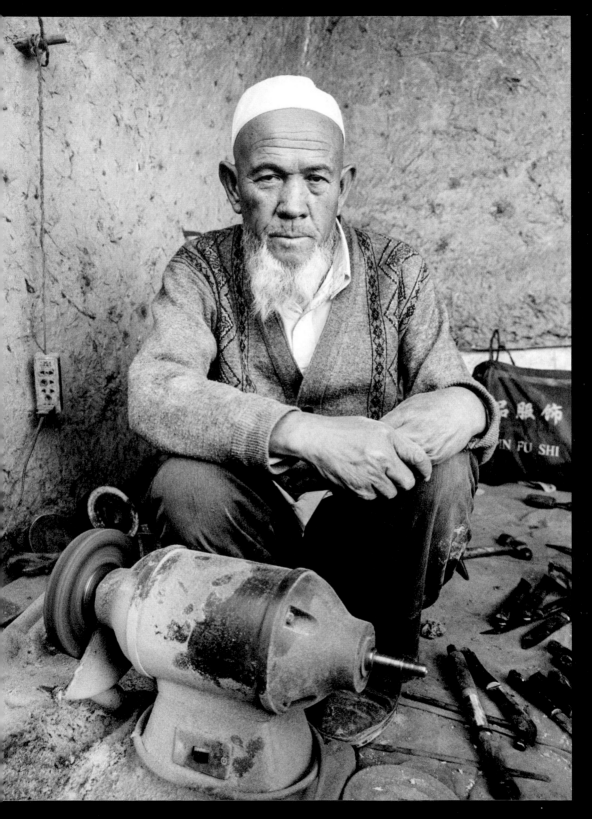

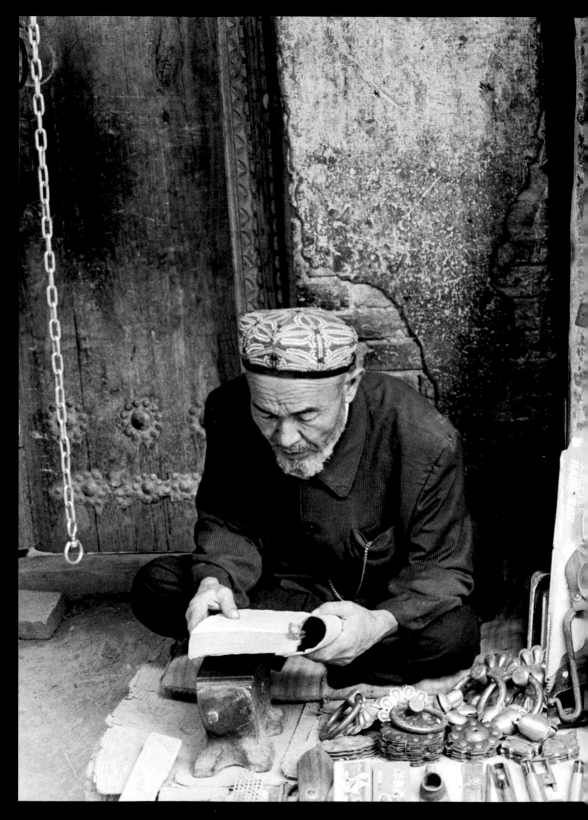

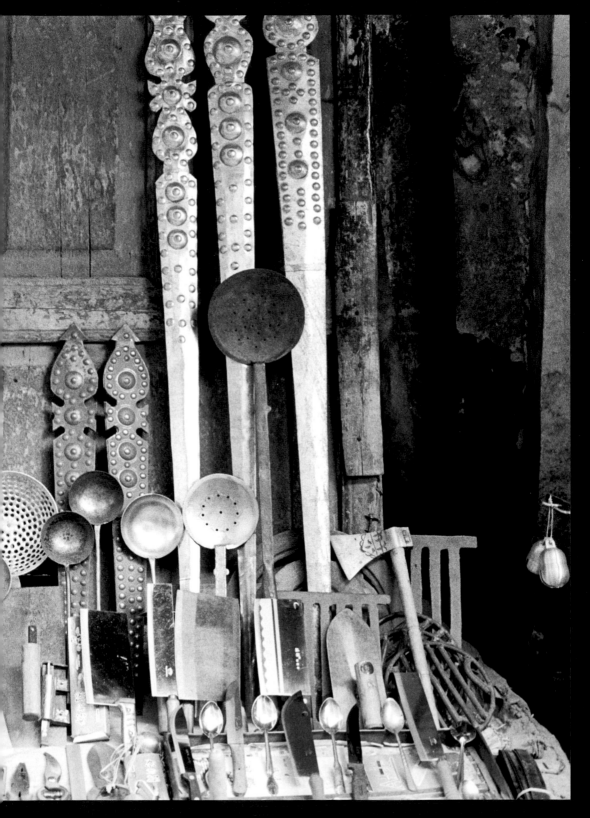

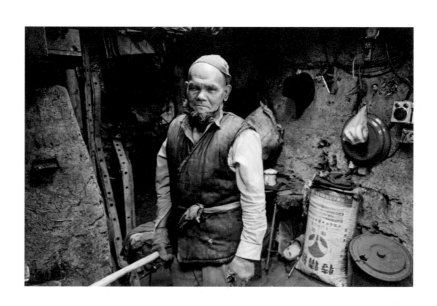

PAGES 140 – 141
A man reads a book while he waits for his next customer at his metalwork stall in a street market in an old neighborhood in the center of Kashgar.

THIS PAGE
LEFT A blacksmith in his workshop in the blacksmiths' market in central Kashgar.

RIGHT Another blacksmith takes a smoke break in the blacksmiths' market in central Kashgar.

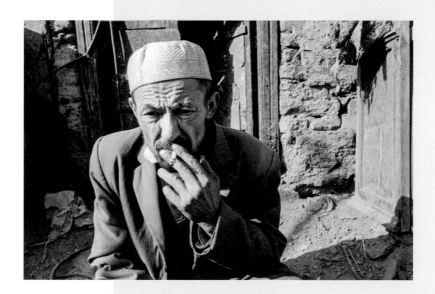

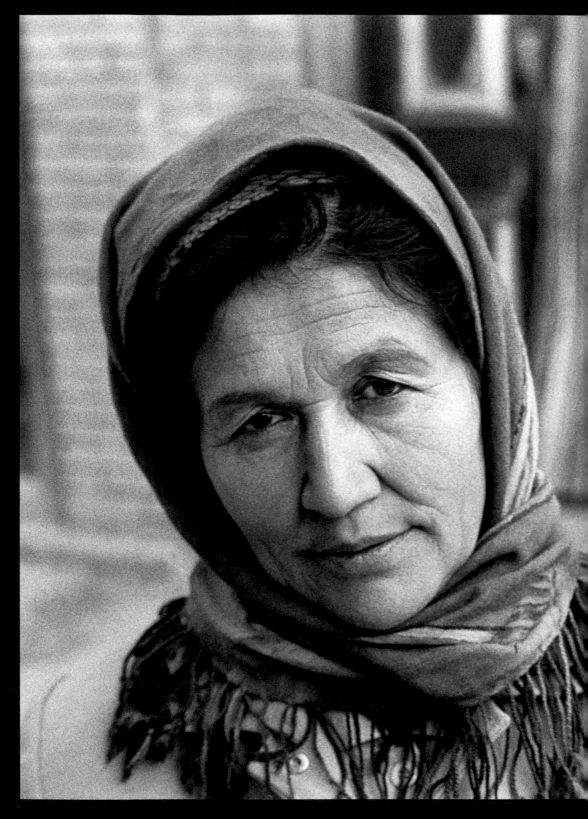

PAGES 144 – 145
A woman stands in front of her
home in Kashgar.

THIS PAGE
A man tends to his bee hives beside
the stand where he sells his honey
on the dirt road outside a village
near Bayan Bulak.

PAGES 148 – 149
A farmer surveys his crops in fields
near the town of Aksu, on the edge of
the fertile Tarim Basin.

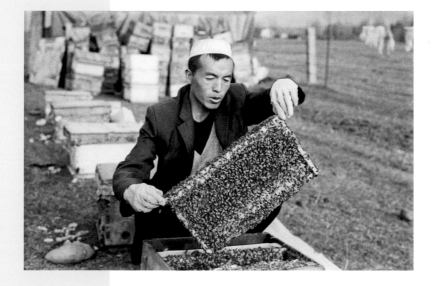

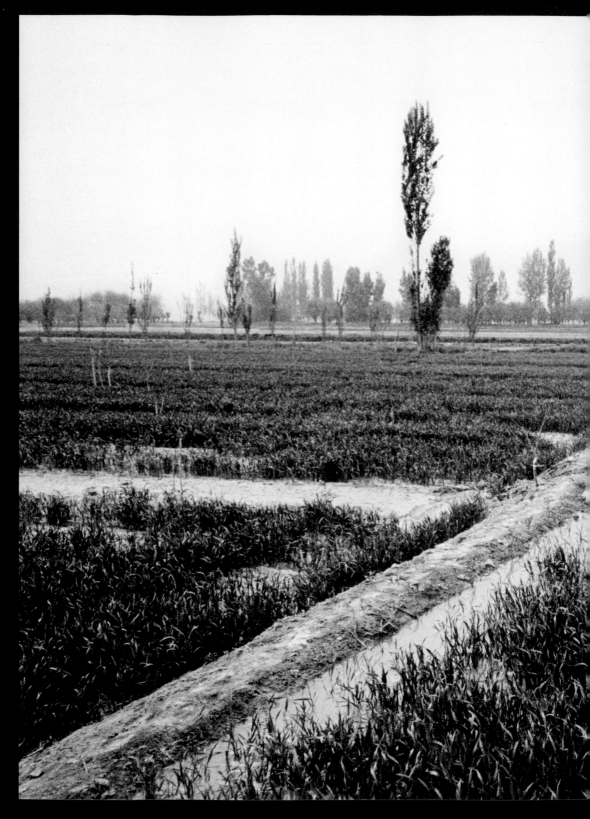

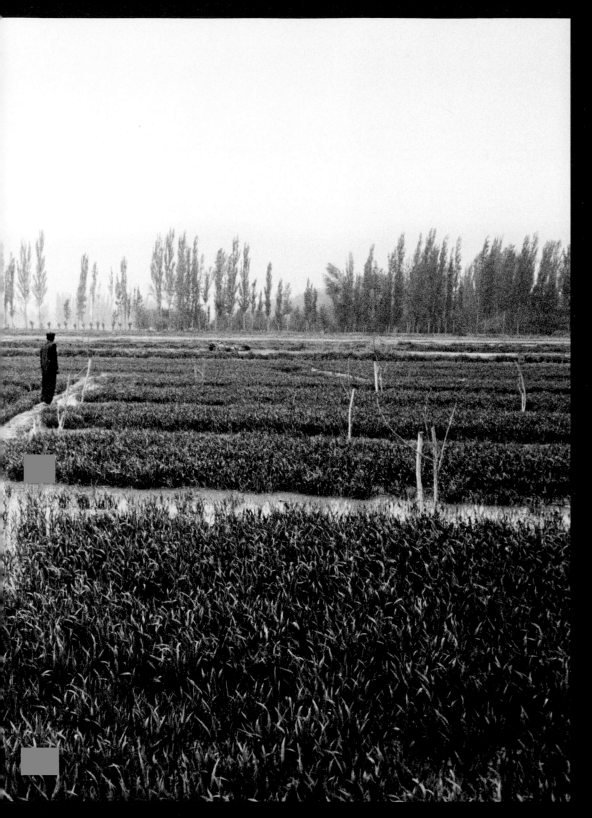

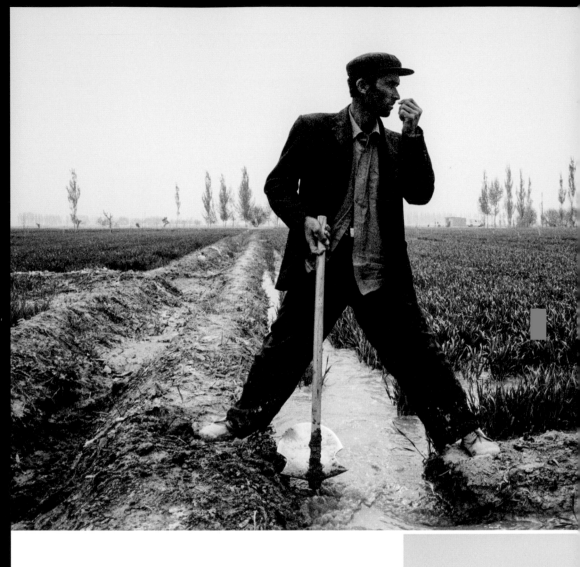
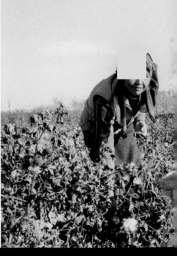

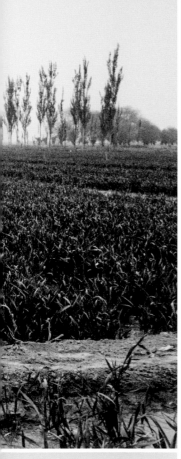

THIS PAGE
MAIN IMAGE A man pauses in his work clearing the drainage canals that irrigate this rice field near Aksu.

BOTTOM, CENTER A young woman picks cotton in fields beside her home in a village near the Kyrgyzstan border.

BOTTOM, RIGHT An elderly farmer carries a shovel as he walks through his rice fields at the edge of a village near Aksu.

PAGES 152– 153
MAIN IMAGE An elderly farmer carries an axe into his field in the countryside near Yining.

TOP, LEFT A woman rests on a muddy bank in her rice field in the countryside near Kucha.

CENTER, LEFT Men and women pick cabbages on a farm near Yining, near the border with Kazakhstan.

BOTTOM, RIGHT A young woman picks cotton while holding her baby in a field near the border with Kyrgyzstan.

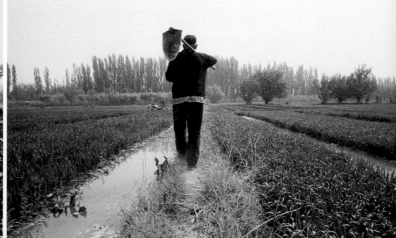

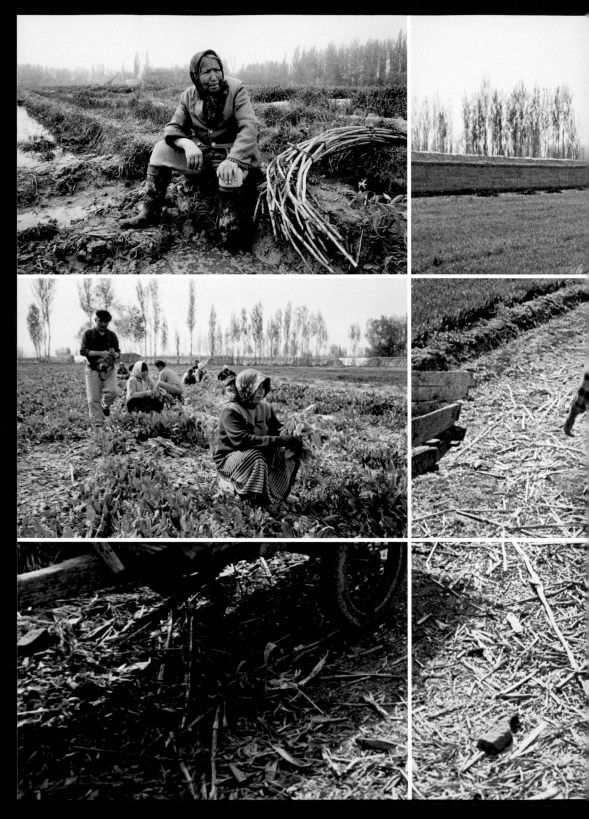

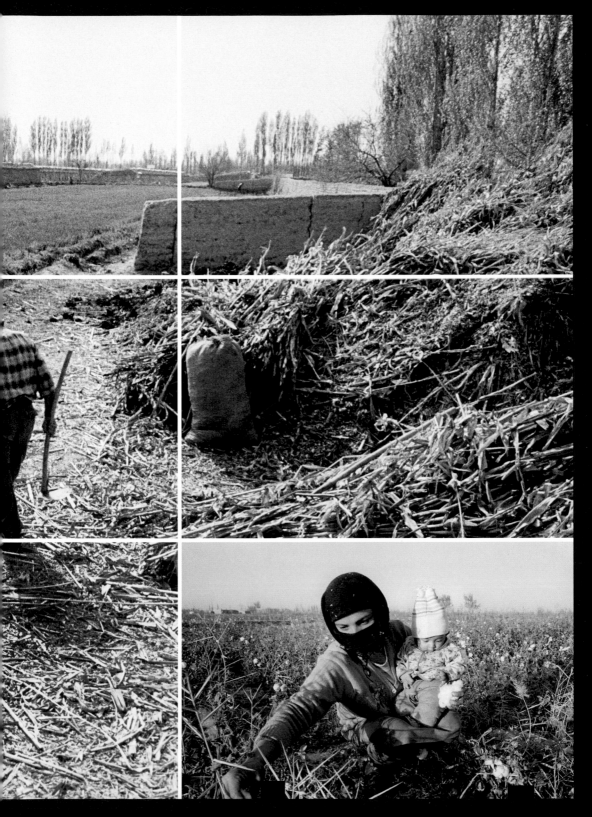

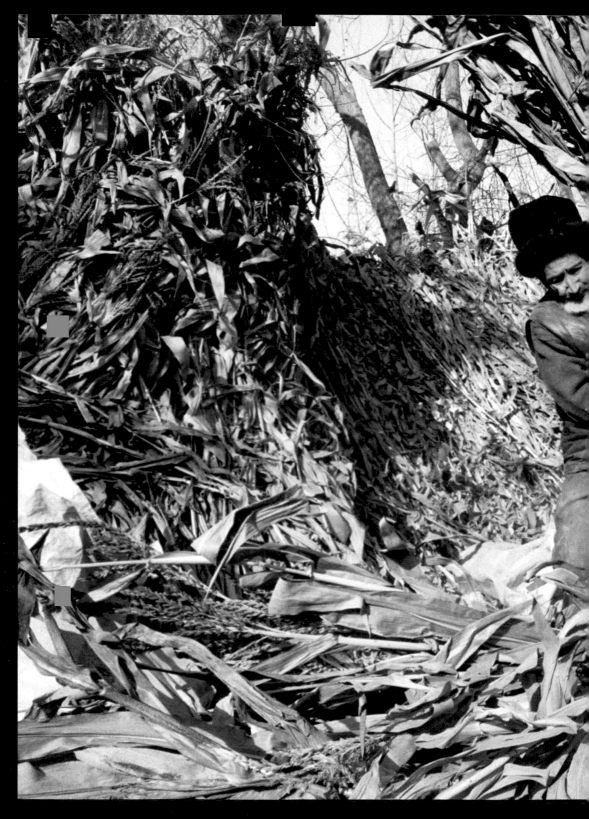

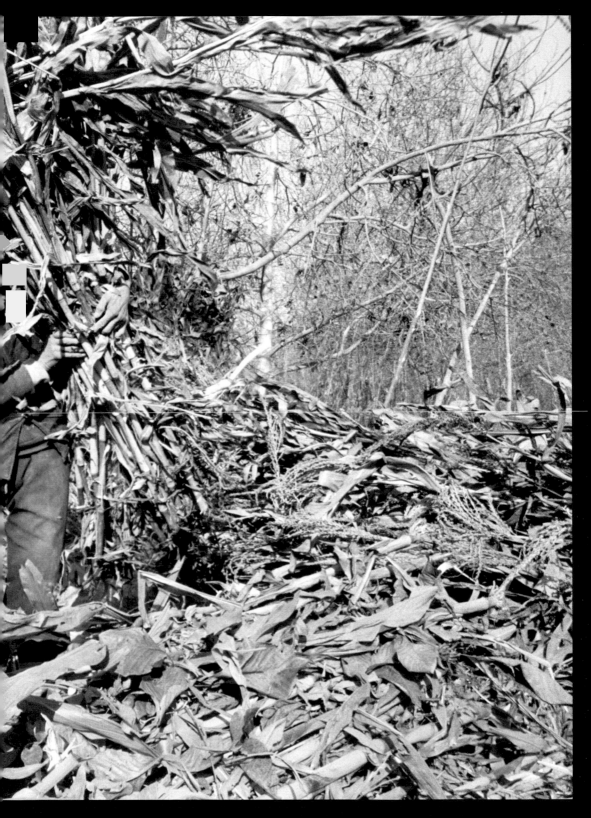

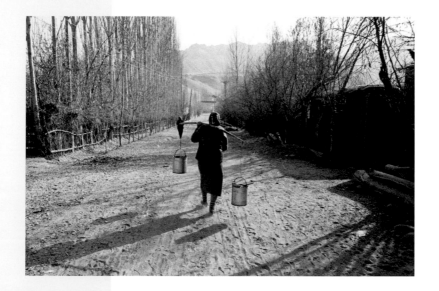

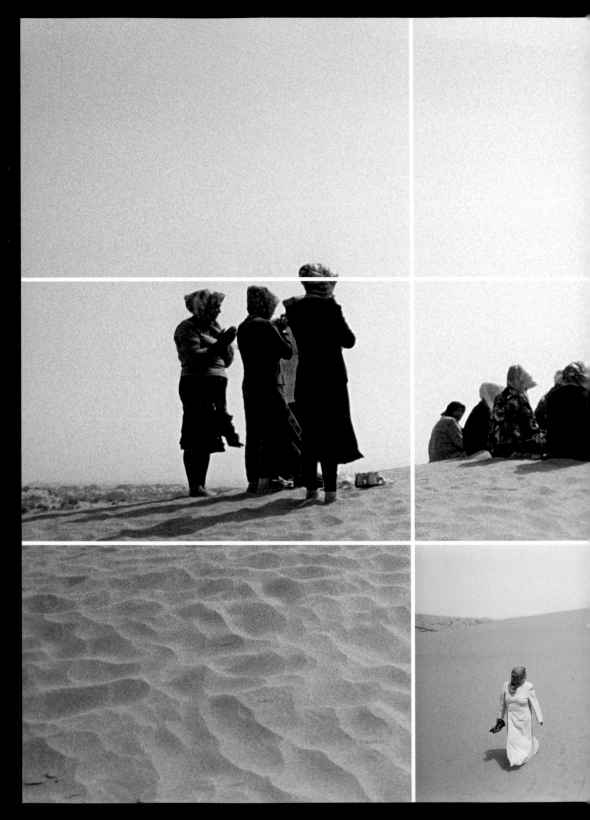

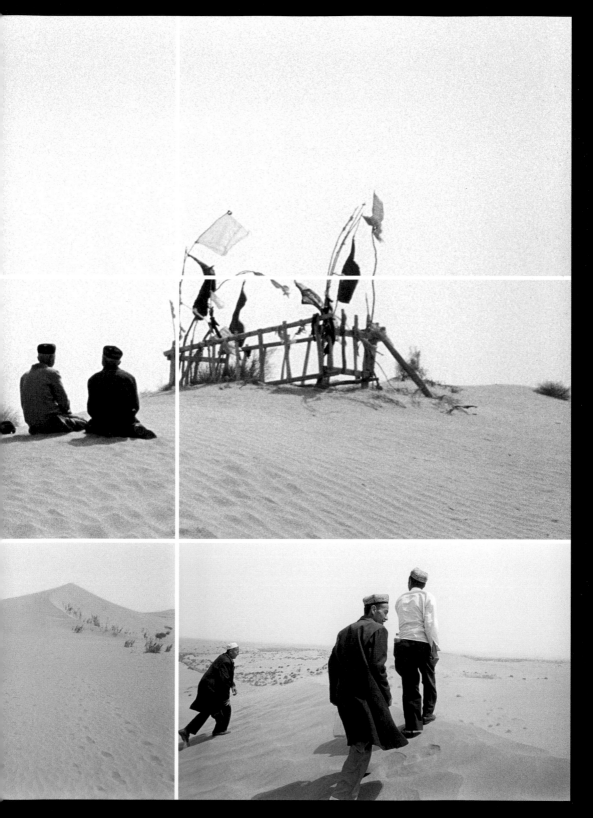

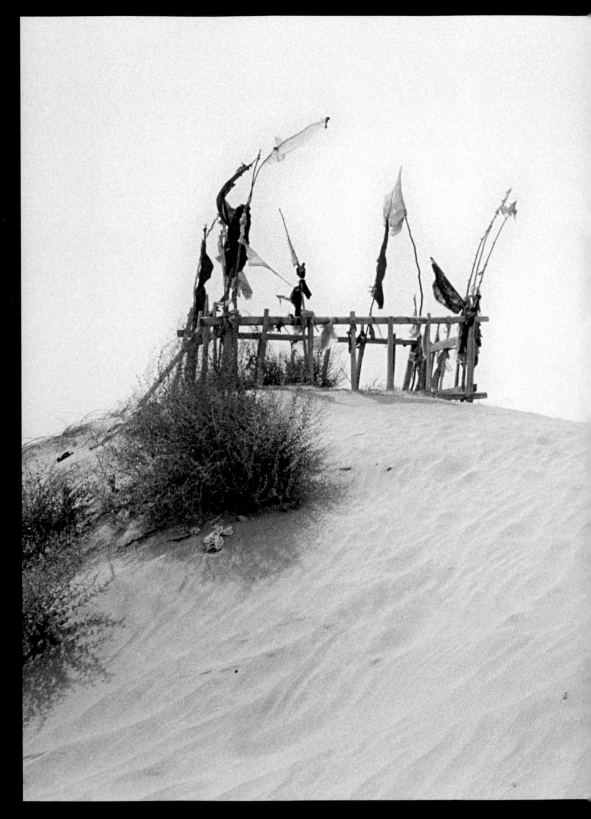

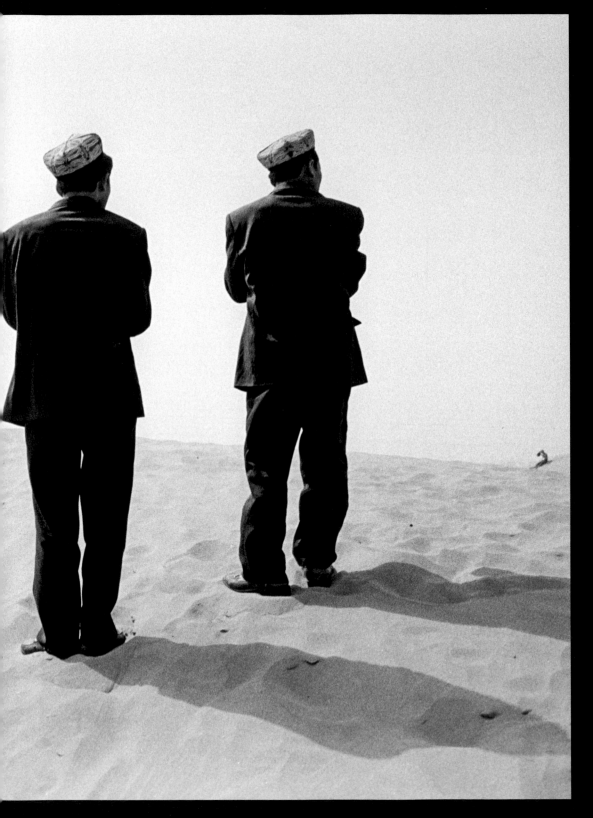

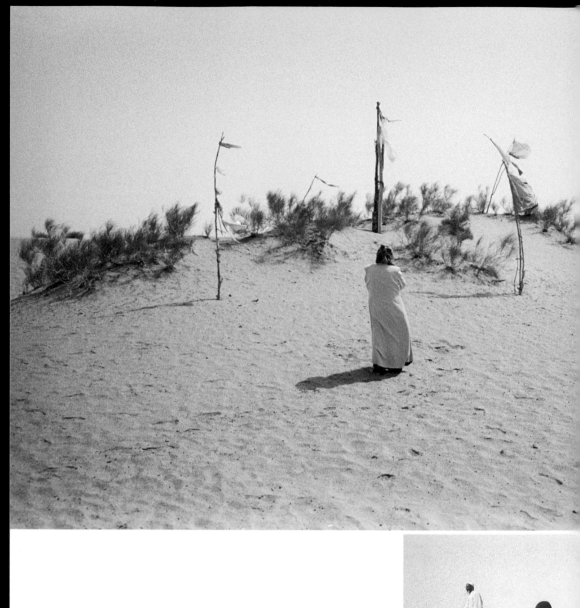
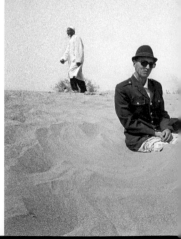

PAGES 160 – 161
The Imam Asim Ancient Tomb is surrounded by a traditional Uyghur wooden fence.

THIS PAGE
MAIN IMAGE Muslim pilgrims like this woman visit the Imam Asim Ancient Tomb for an Islamic festival. The temple is located in the middle of a desert about 20 km outside the city of Khotan.

BOTTOM, CENTER Muslim pilgrims, with their legs buried in the sand, pray at the Iman Asim Ancient Tomb.

BOTTOM, RIGHT Muslim pilgrims wash their hands and feet at a waterpipe in the desert beside the Imam Asim Ancient Tomb.

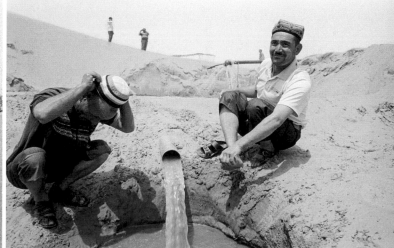

Men and women pray separately at the Imam Asim Ancient Tomb during an Islamic festival.

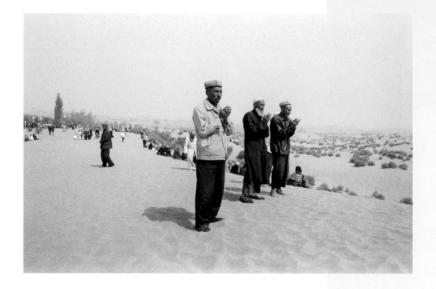

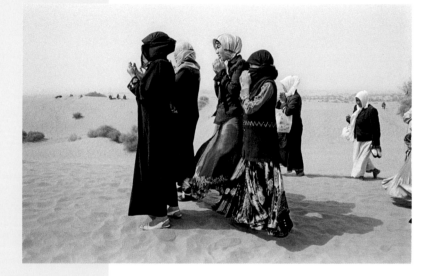

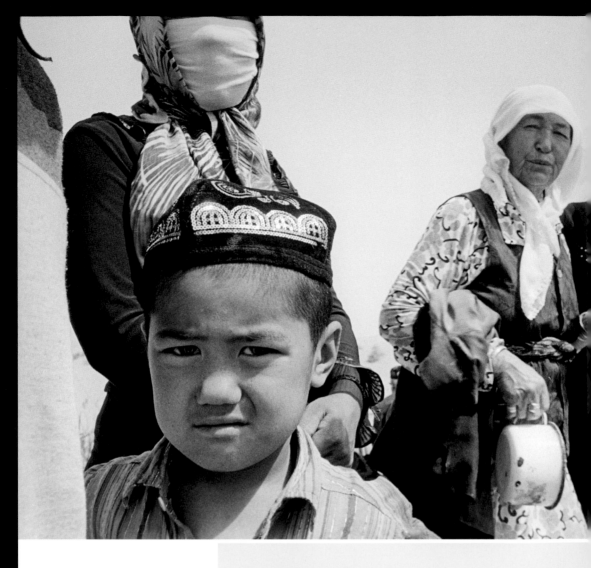

MAIN IMAGE The Imam Asim Ancient Tomb is a site of pilgrimage for Muslims from all corners of Xinjiang and beyond.

CENTER, RIGHT A group of Muslim pilgrims sit and rest for a while in the sand dunes beside the Imam Asim Ancient Tomb.

BOTTOM, RIGHT Entire families trek through the sand dunes to pray at the Imam Asim Ancient Tomb.

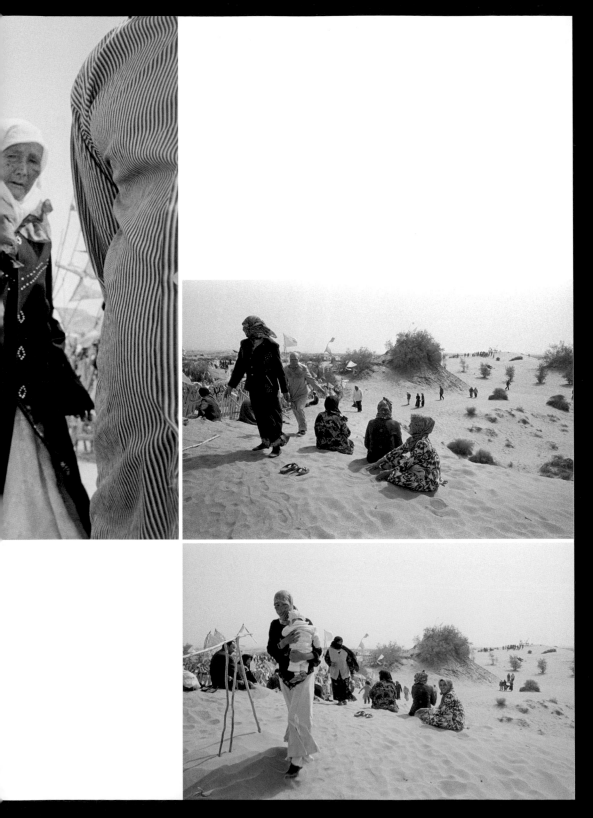

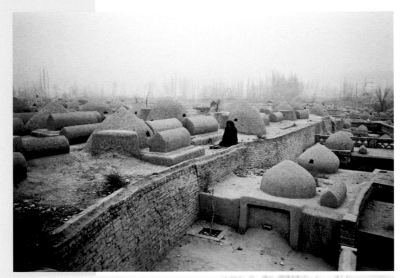

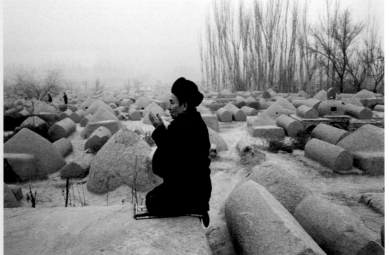

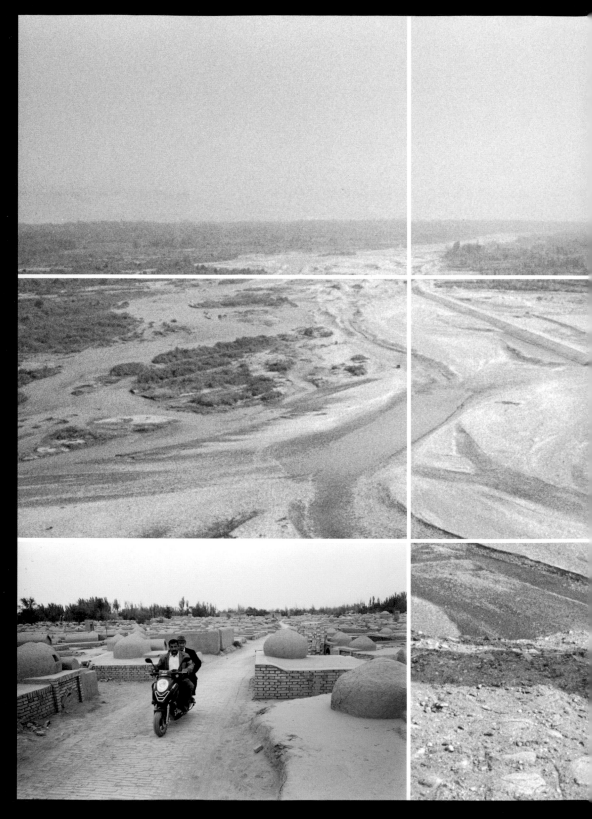

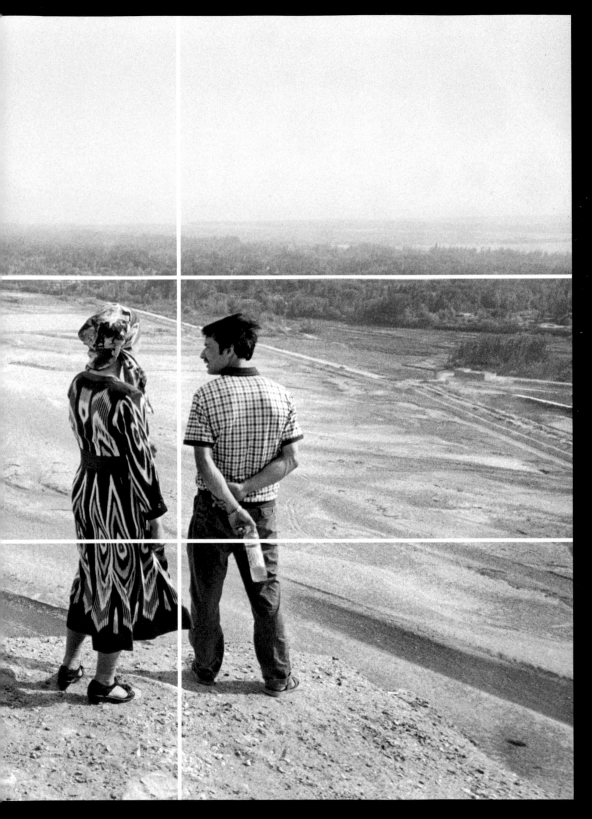

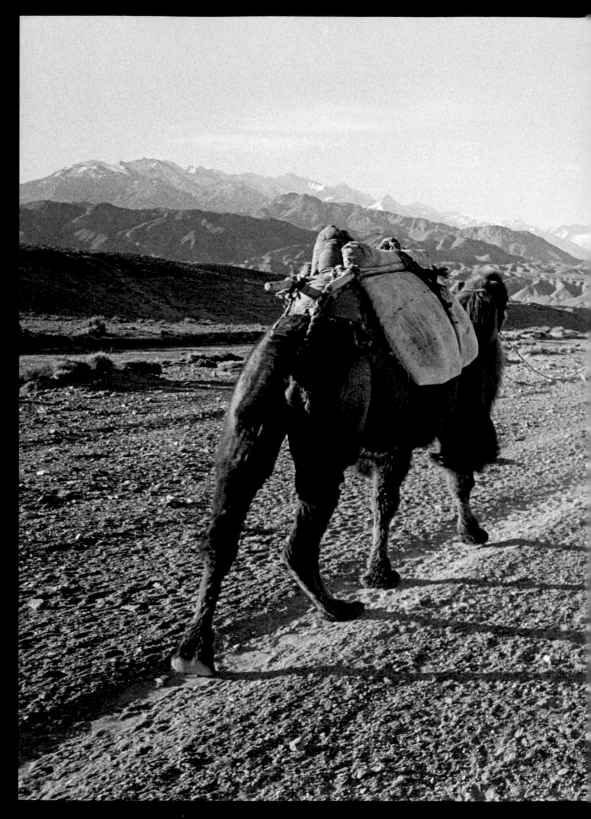

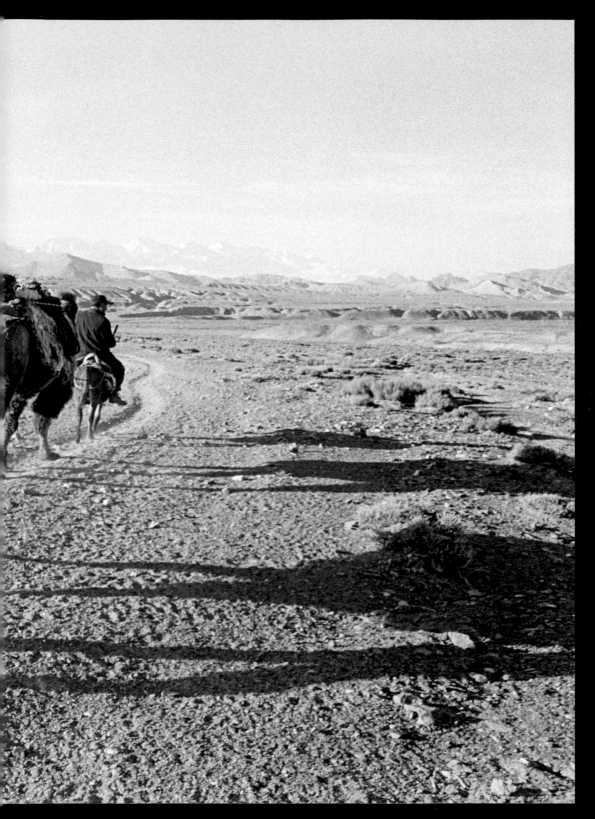

THIS PAGE
MAIN IMAGE Animal waste is an important fuel source in this remote region near the border with Kyrgyzstan.

BOTTOM, CENTER Women collect water from the river in a remote region on the border with Tajikistan.

BOTTOM, RIGHT A woman stacks bags of animal waste for loading onto a cart near the town of Irkeshtam on the border with Kyrgyzstan.

PAGES 176 – 177
MAIN IMAGE In the distance, beyond this vast empty valley, lie the mountains of Kyrgyzstan.

CENTER, RIGHT Wild Bactrian camels – similar to this one standing in a dry riverbed near the border with Kyrgyzstan – are a rare and endangered species.

BOTTOM, CENTER An old farmer walks slowly across a barren landscape near the border with Kyrgyzstan.

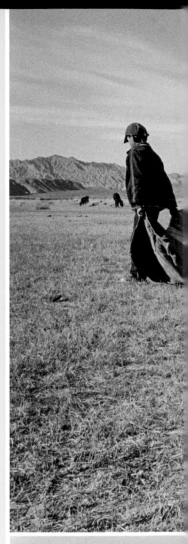

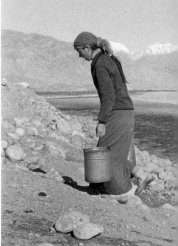

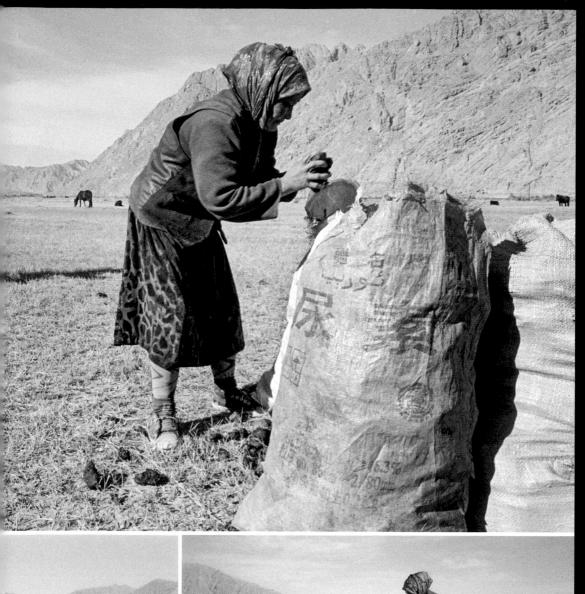

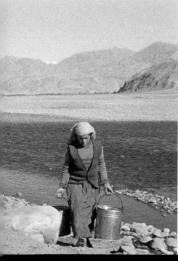

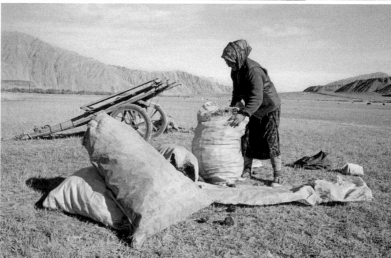

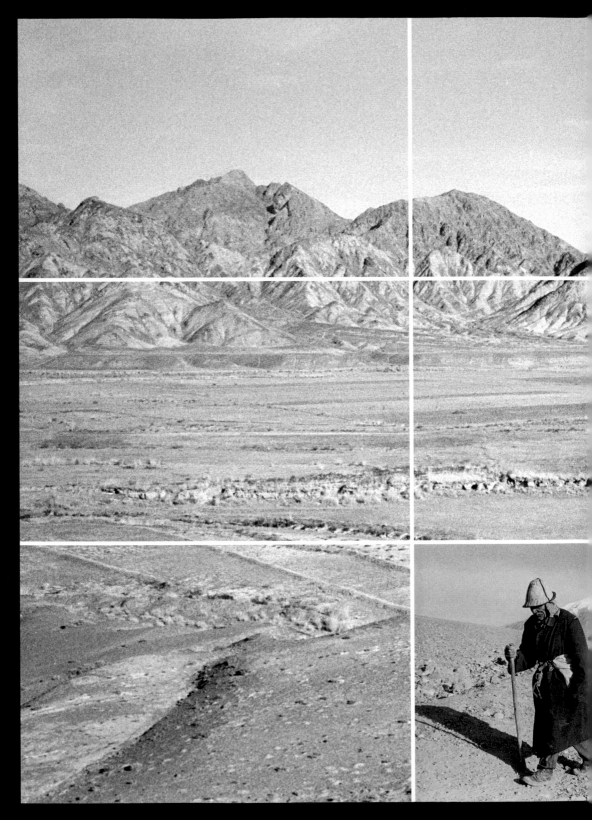

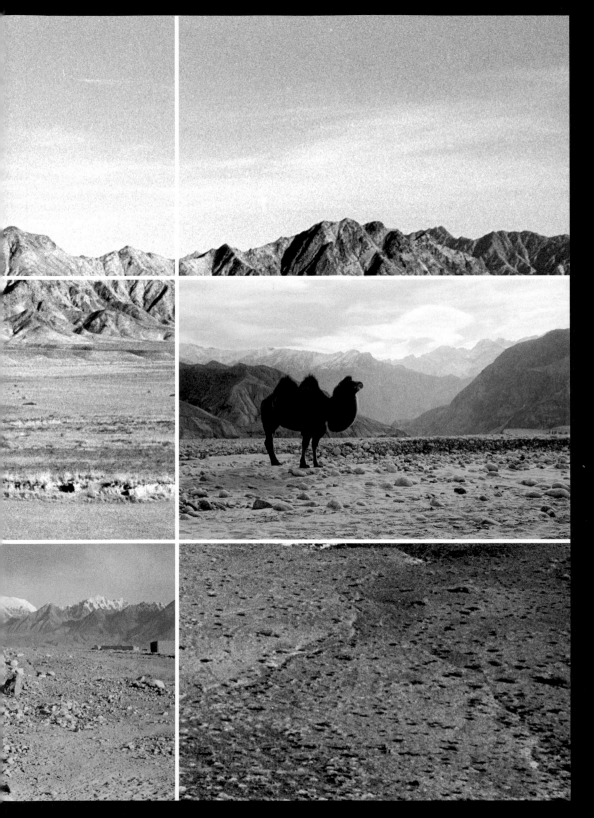

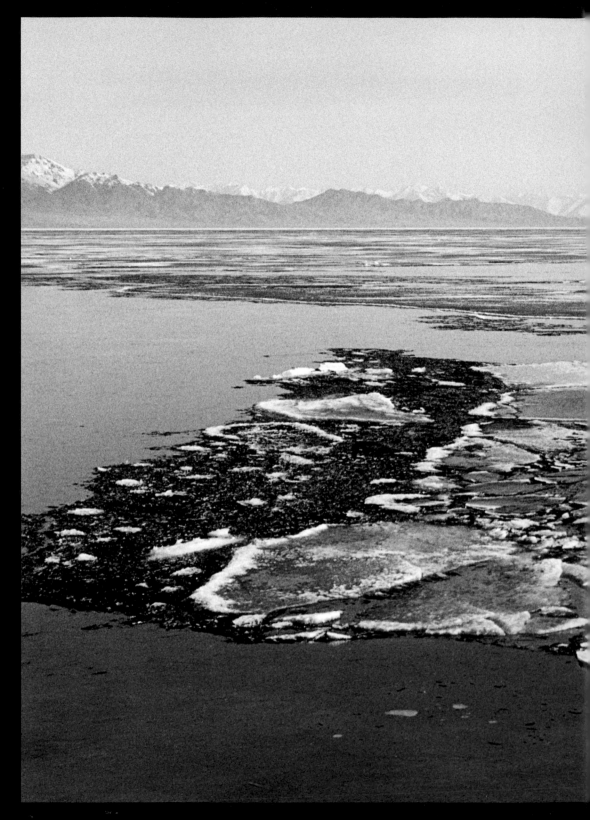

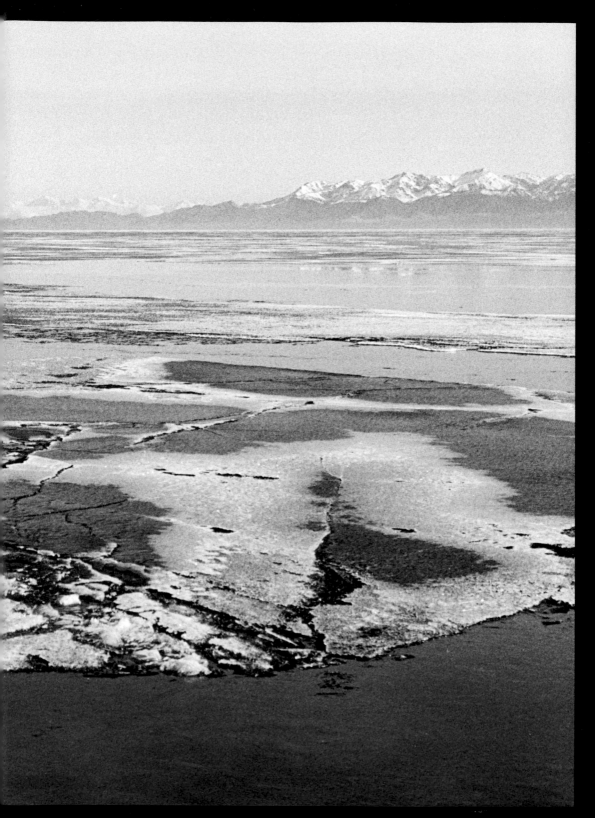

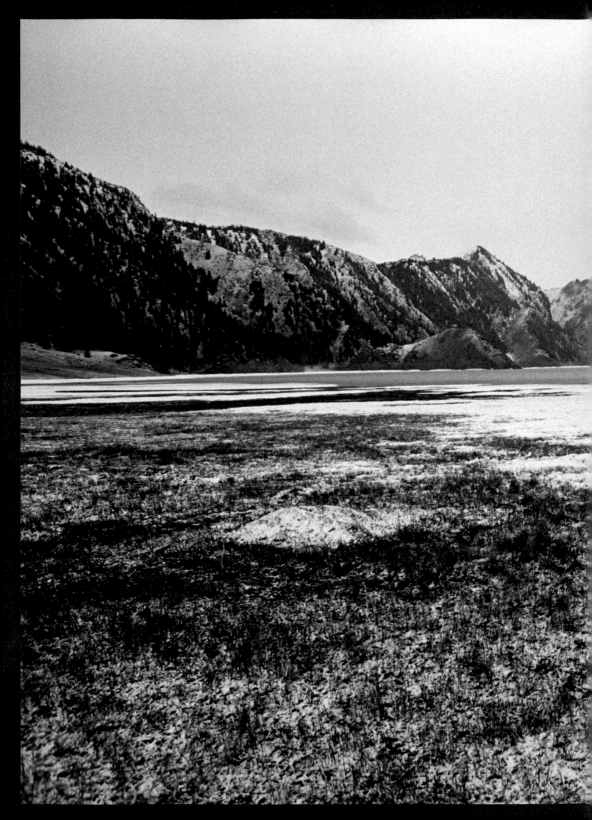

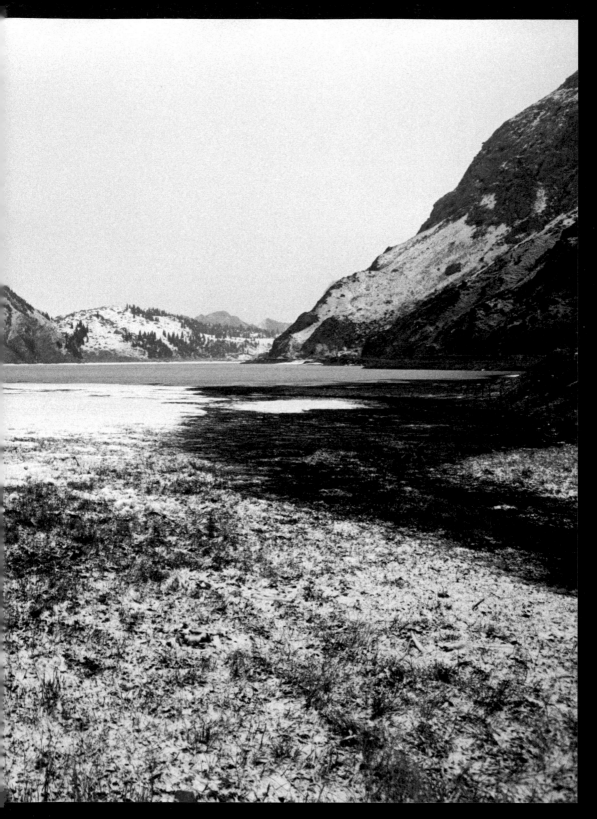

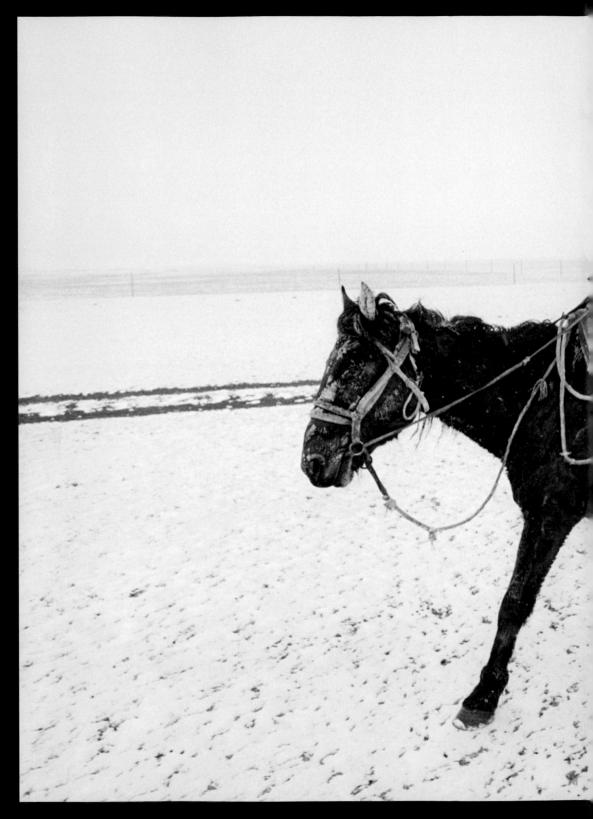

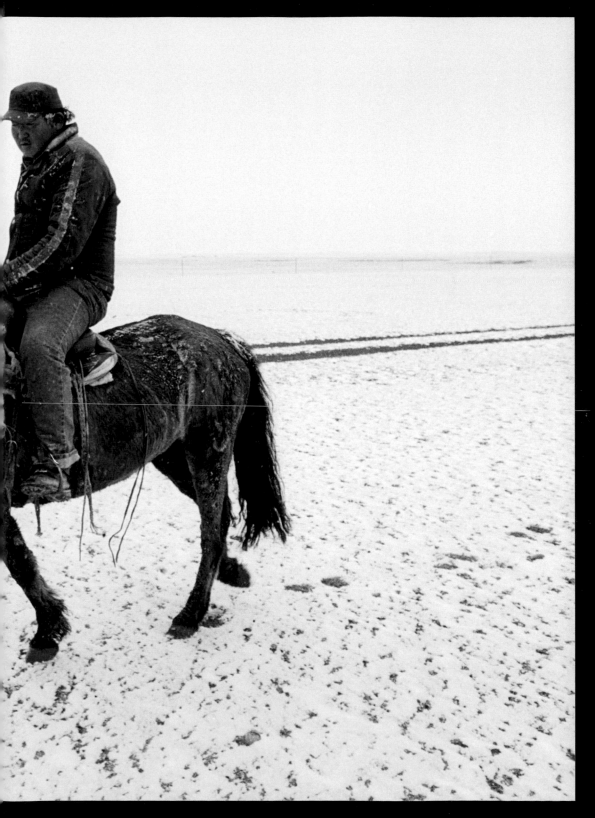

PAGE 178 — 179
In the winter, ice forms on glacial Sayram Lake, beyond which are the Tian Shan Mountains and Xinjiang's border with Kazakhstan.

PAGES 180 — 181
There are many small lakes — frozen in the winter like this one — on the grasslands amidst the mountains near the village of Bayan Bulak.

PAGES 182 — 183
The winters are harsh on the Bayan Bulak grasslands.

THIS PAGE
In the distance beyond this valley lies the Karakoram Highway, which runs through the Khunjerab Pass and links China with Pakistan.

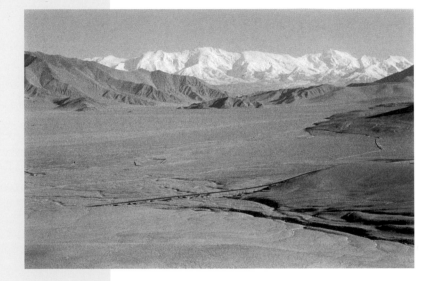

Acknowledgments + Biographical Note

Acknowledgments

First I would like to thank the wonderful people of Xinjiang, including all of the ethnicities and religions of the people there, for making each of my visits to the region a journey of joy and sheer photographic pleasure.

At no time in making this book did I sense or feel any hostility towards my presence or my work in the region. The legendary hospitality of the inhabitants of Xinjiang, made famous during the Silk Road era, remains true to this day.

Also, I would like to give a special thanks to Abdul, Jasmine Bian, Giorgio Baravalle, Jane Smith, Chad Ingraham, Jesper Sorensen, Bob Carnie and Kevin Viner.

Biographical Note

Born in Toronto, Canada, Ryan Pyle spent his early years close to home. After obtaining a degree in International Politics from the University of Toronto in 2001, he realized a life-long dream and traveled to China on an exploratory mission. In 2002 Ryan moved to China permanently and in 2004 became a regular contributor to the *New York Times*. In 2009 he was listed by *PDN Magazine* as one of the 30 emerging photographers in the world. In 2010 Ryan began working full time on television and documentary film production and has produced and presented several large multi-episode television series for major broadcasters in the USA, Canada, UK, Asia, China and continental Europe.

Ryan Pyle is an award winning photographer, television presenter, filmmaker and author.

Recent Awards

2013 – Governor General of Canada – Gold Medallion
2010 – PDN Photo Annual – Winner
2009 – PDN 30 – Emerging Photographer
2009 – Magenta Foundation – Flash Forward Emerging Photographer

Television Series

2014 – Extreme Treks: Sacred Mountains of China – Presenter / Producer
2014 – Tough Rides: India (Season 2) – Presenter / Producer
2013 – Touch Rides: China (Season 1) – Presenter / Producer

Publications

2014 – Chinese Turkestan
2014 – The India Ride
2013 – The Middle Kingdom Ride

-

For more about Ryan Pyle, visit: www.ryanpyle.com

Chinese Turkestan

Published by Ryan Pyle Productions
www.ryanpyle.com

Chinese Turkestan.
© Copyright 2014 by Ryan Pyle Productions
All rights reserved.
ISBN-13: 978-0-9928644-0-8

Ryan Pyle Productions books may be purchased for educational, business, or sales promotional
use. For information, please write:
Special Markets, Ryan Pyle Productions
c/o Hillier Hopkins LLP,
First Floor, Radius House,
51 Clarendon Road,
Watford, Hertfordshire,
WD171HP, United Kingdom.

FIRST EDITION

Design: de.MO
Printed in Singapore.

-

Library of Congress Cataloging-in-Publication Data
 Pyle, Ryan
 Chinese Turkestan: A Photographic Journey through an Ancient Civilization / Ryan Pyle.
 p. cm.
ISBN 978-0-9928644-0-8
1. China – Photography. 2. Fine Art. Anthropology. History.
China. I. Title